ABSTRACT
Landscapes!

Nature Coloring Book Vol. 2 - Grayscale Edition

GRAYSCALE COLORING BOOKS

Coloring Therapists
STRESS RELIEVING COLORING ACTIVITIES

Coloring Therapists LLC
40 E. Main St. #1156
Newark, DE 19711
www.coloringtherapists.com

Copyright 2016

How Does an Adult Coloring Book Help Relieve Stress?

Years ago, coloring was for children. Although occasionally an adult who was babysitting would color with the child, that adult wouldn't normally pick up a coloring book on their own. Recently, a new trend in coloring books for adults has changed the way adults relieve stress. Coloring books for adults has reached an all-time high with many books on bestseller lists. While this may be a fun hobby for some, others find serious stress relief from coloring inside these books.

Adults who color often call themselves colorists, and while coloring may not be curing any serious diseases, it's helping people cope with various issues in their lives. Therapists have often used art therapy as a way to provide therapy in conjunction with talking about the patient's problems. When people cannot put their anguish or depression into words, they've been asked to express themselves through art. When a person considers themselves bad at art, they aren't able to get the benefits that others might get from using art therapy as a tool. With coloring, there's no special talent needed. Everyone can color between the lines to get the benefits of stress relief.

Four Benefits to Coloring

Dementia and Alzheimer's:

Art therapy and coloring can be used with dementia and Alzheimer's patients to keep them grounded in the world around them. It can be used as a way for them to remain calm when they feel out of control too.

Blood Pressure:

Like many other hobbies, coloring can help lower blood pressure. It can help people relax especially when combined with color therapy. The colors blue and green have been proven to provide relaxation. Pink is soft innocence while gray is considered peaceful and quiet. These colors used together can provide art therapy as well as color therapy.

Focus and Meditation

As far back as the turn of the century, psychologists like Carl Jung would have his patients color mandalas to focus their attention. While we seem to consider coloring to be for children and the childish, it can be a great way to focus the mind and release stress through a meditative state of focus.

Reduce Anxiety

When it comes to coloring mandalas or any other complex form, there have been studies that suggest it beats randomly coloring on a blank piece of paper. In the Art Therapy Journal of the American Art Therapy Association, a study in 2005 involved over 80 undergraduates. They experienced reduced anxiety when coloring mandalas over coloring a blank piece of paper.

What Happens When We Color?

You don't have to have PTSD or dementia to benefit from the concepts that make art therapy successful. The inability to focus on tasks is a symptom of stress and anxiety, which can be alleviated through the use of coloring books.

Adults who spend time coloring are entering a state of focus that allows them to relax much like meditation does. When entering a meditative state, they're able to let go of thoughts that are causing anxiety. Often, the brain is switched off from negative thoughts and more narrowed in on positive ones. It can be calming to the brain as well as the body. The repetition of patterns is often one of the most calming aspects of the coloring process. It is complex enough to seize the person's entire focus and attention while providing them a way to bring that image into a semblance of order through color.

As a Nighttime Activity

When we spend the hours before bed on our devices like smartphones and tablets, we are exposing our bodies to the light emitted by them. These lights can disrupt our circadian rhythms, which can contribute to a change in sleep patterns. It also reduces levels of melaton in that can cause sleep interruption. Coloring before bed can help colorists relax and get their bodies settled into a state that helps them sleep. It won't disturb the levels of melatonin in the body, or disturb the circadian rhythms needed for good sleep patterns.

Often, we spend time laying in bed thinking about our day and agonizing over things we need to do the next day. When colorists spend time with their coloring books before bed, they might find themselves dropping right into sleep because they're more relaxed.

Buying Your First Book

If you've never purchased an adult coloring book before, you can find them at your local department or book store. They've become so popular that many stores carry a variety of books, so you'll be able to find the most appealing patterns and designs from pages of sea life to animals in the wild and for the adventureous types who would like a laugh, coloring books on swear words and sex positons. For those who don't have access to a bookstore in their area, there are plenty of online venues where you can purchase a coloring book. It's important to read reviews before purchasing. You'll also need to think about the type of coloring implement you'll use. You can borrow crayons from your kids, or go completely artistic with colored pencils or markers.

You'll want a medium that doesn't bleed through the pages, or a book with thick pages if you're using markers. Make sure to check the reviews for points that are important to you. To start, you can always find pages online that can be printed out from the computer, but once you get the hang of it, you'll want to purchase your own book. Part of the process is seeing the book fill up and being able to look back on past colored pages.

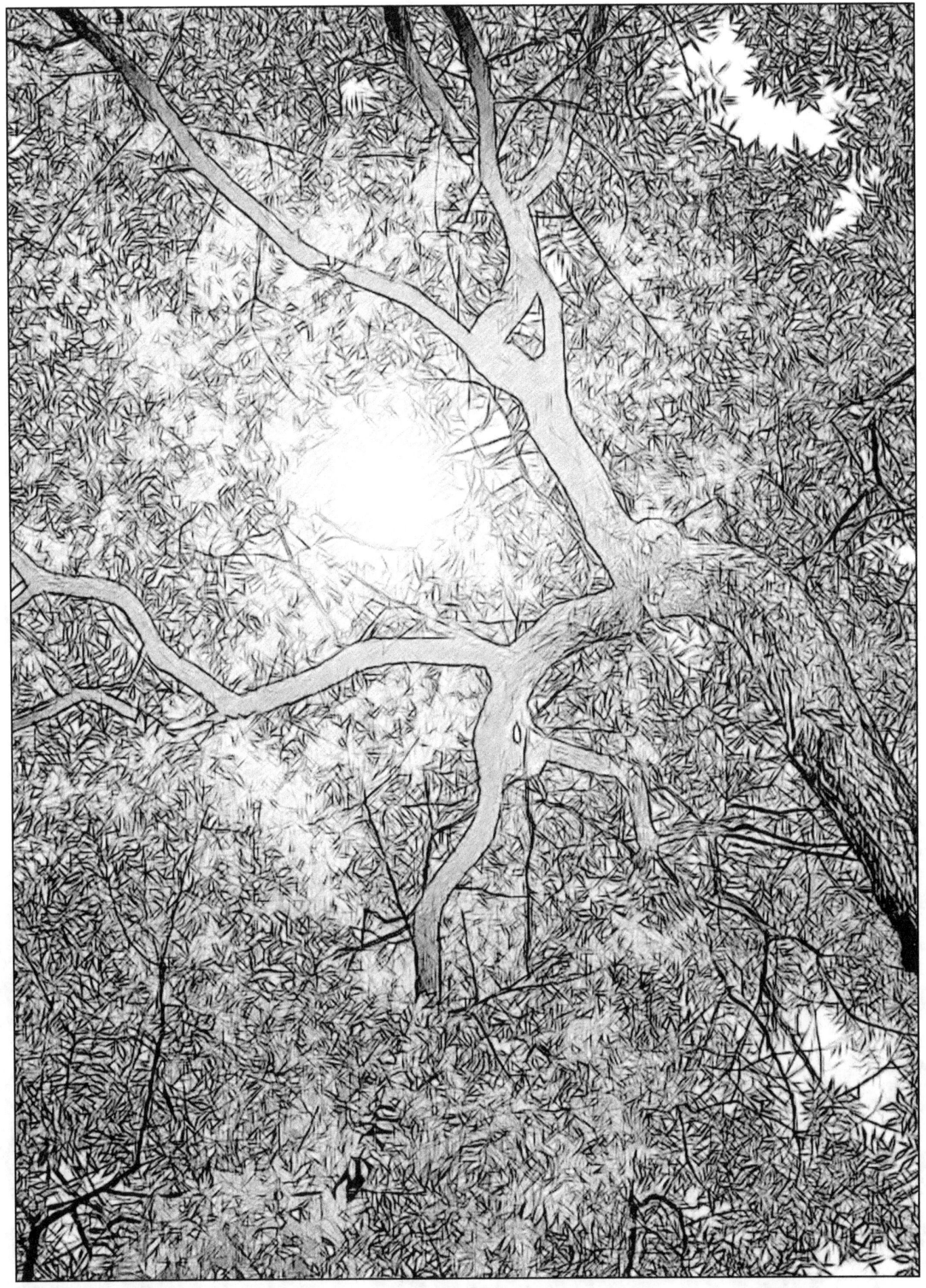

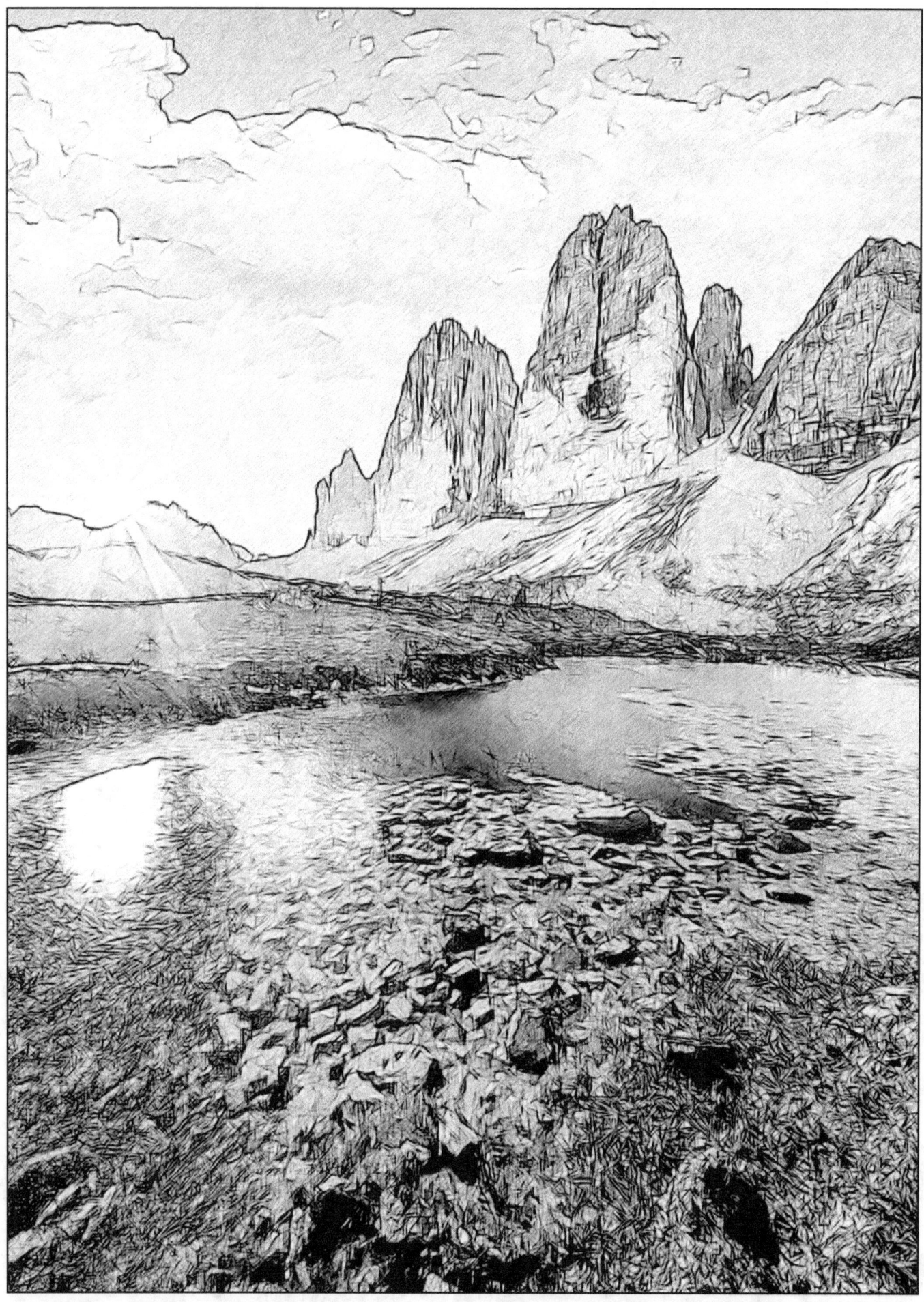

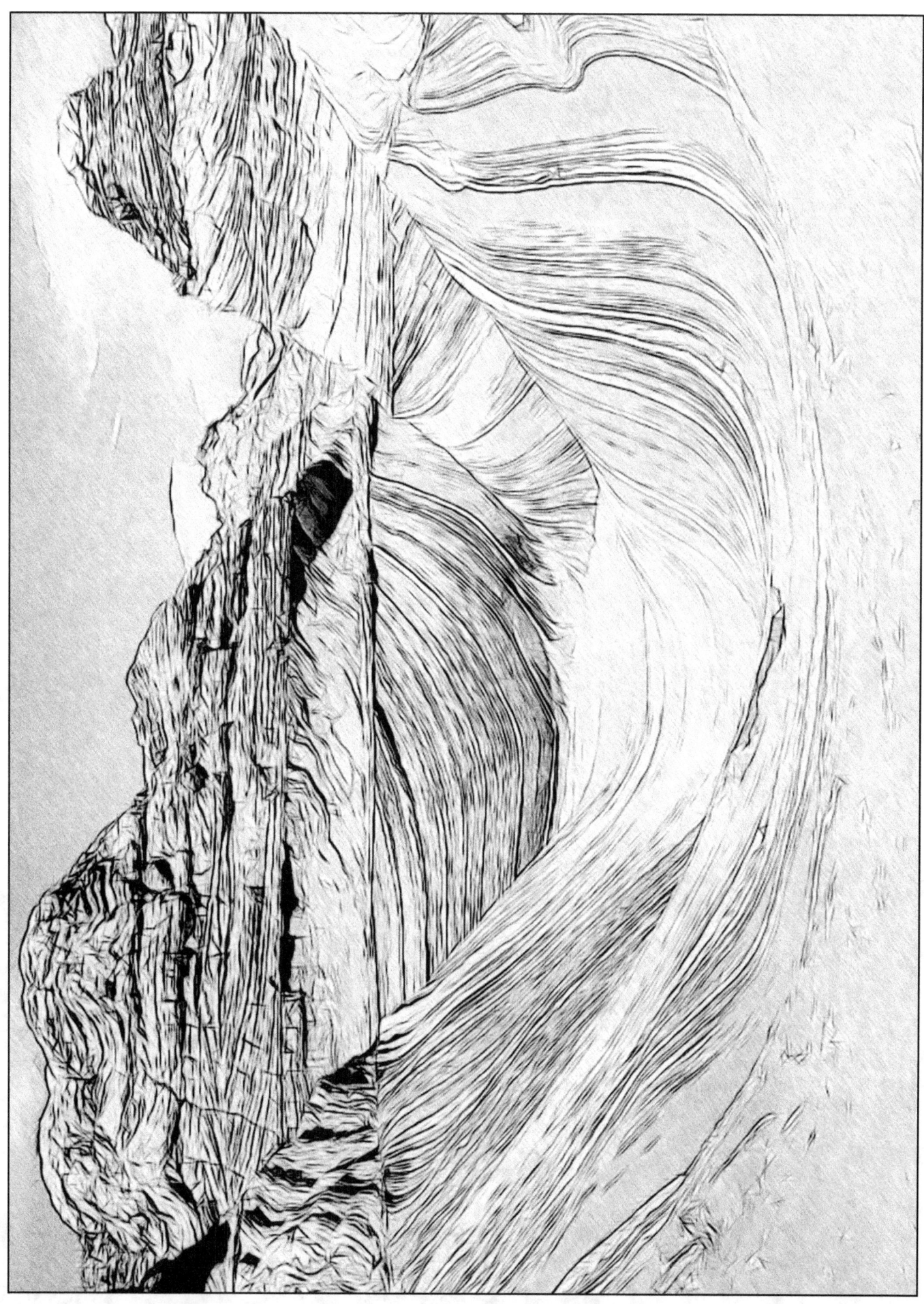

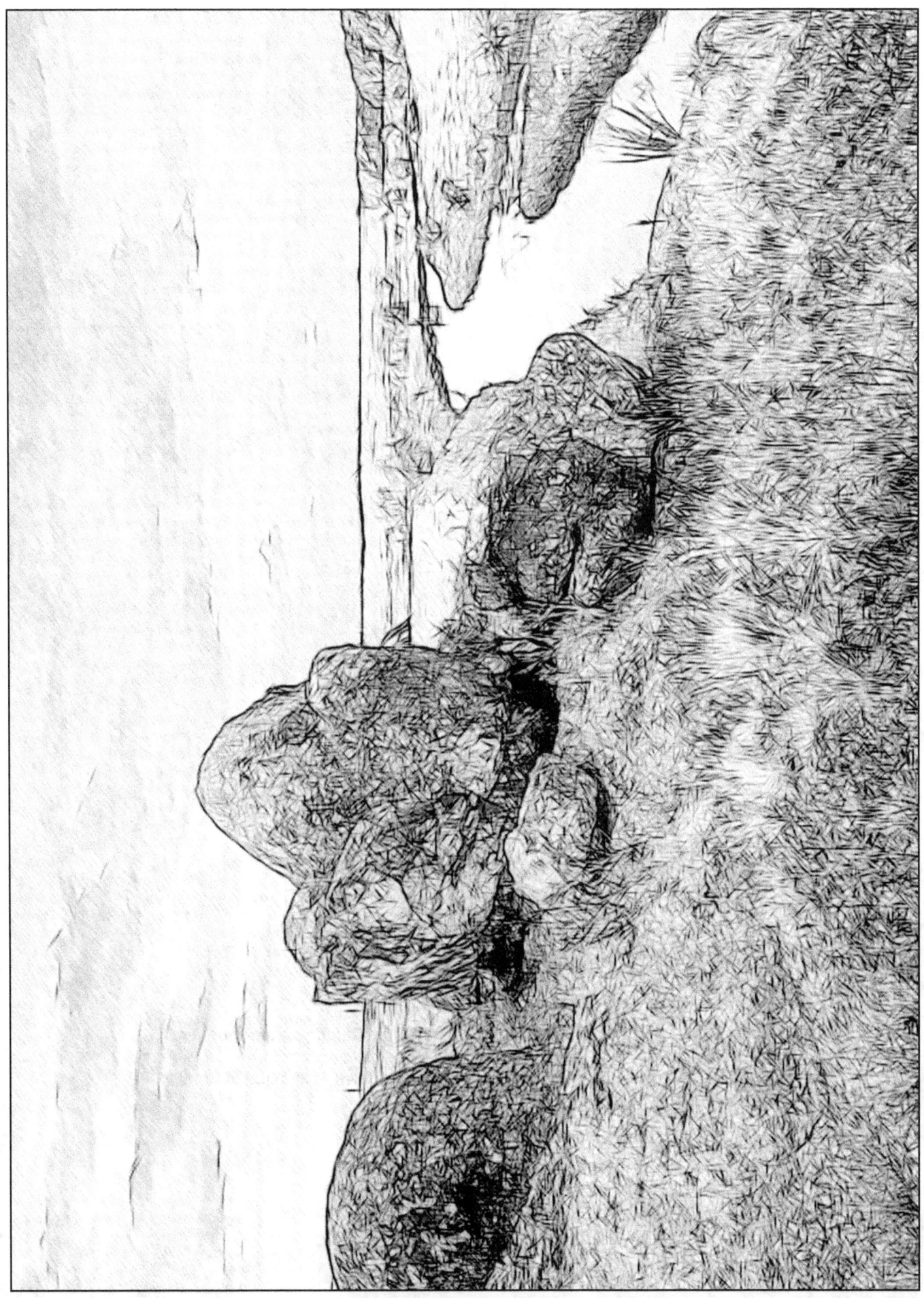

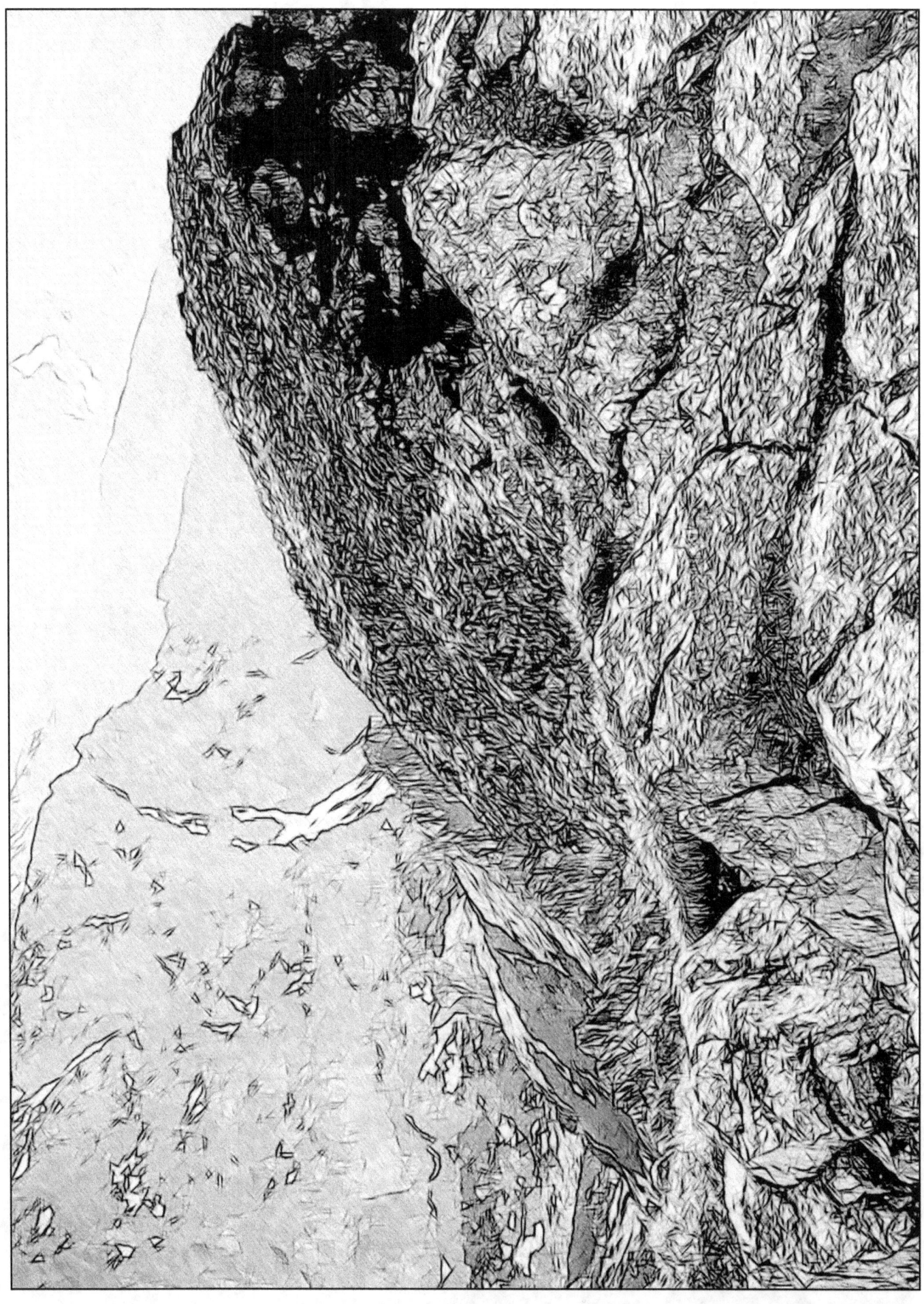

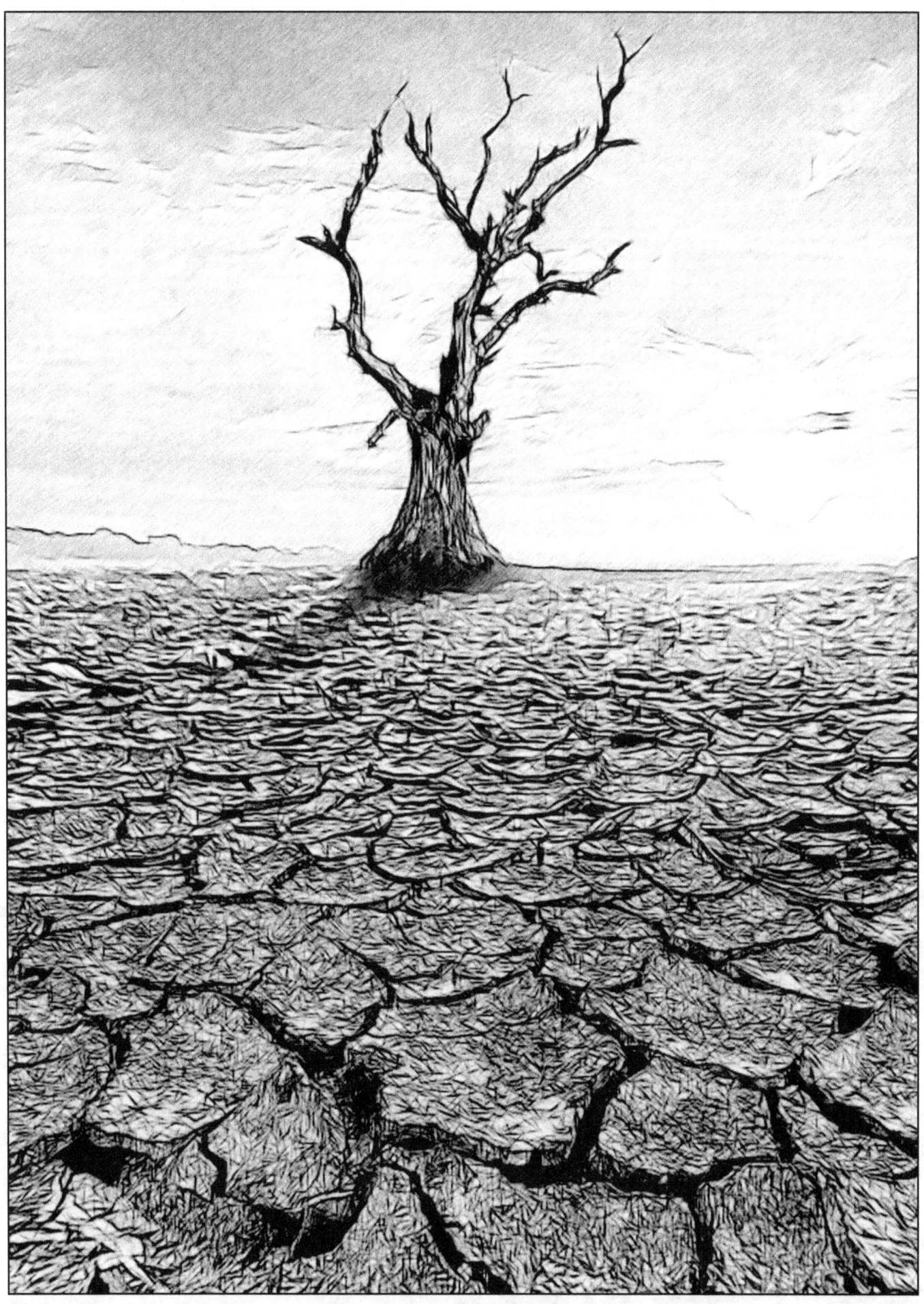

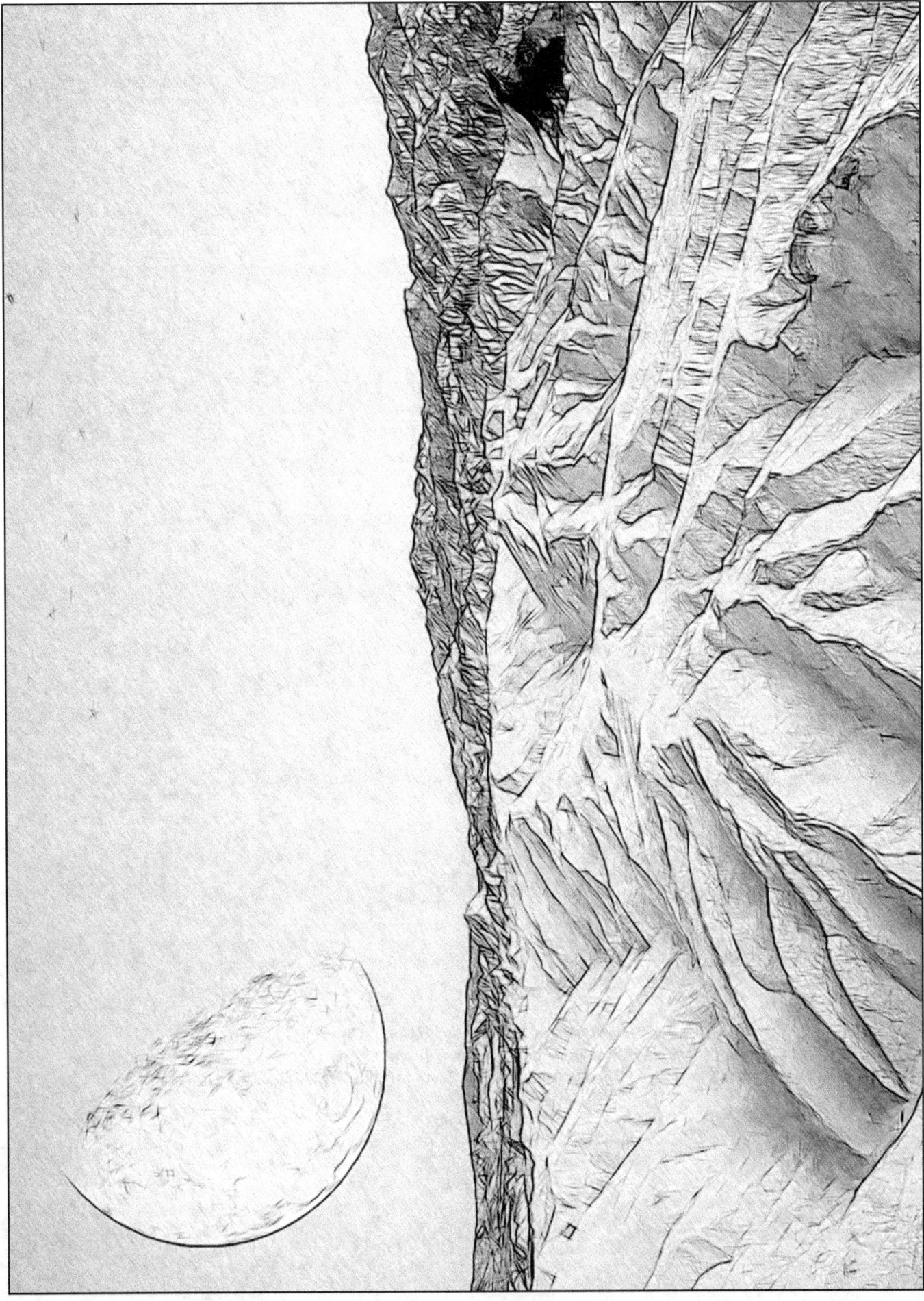

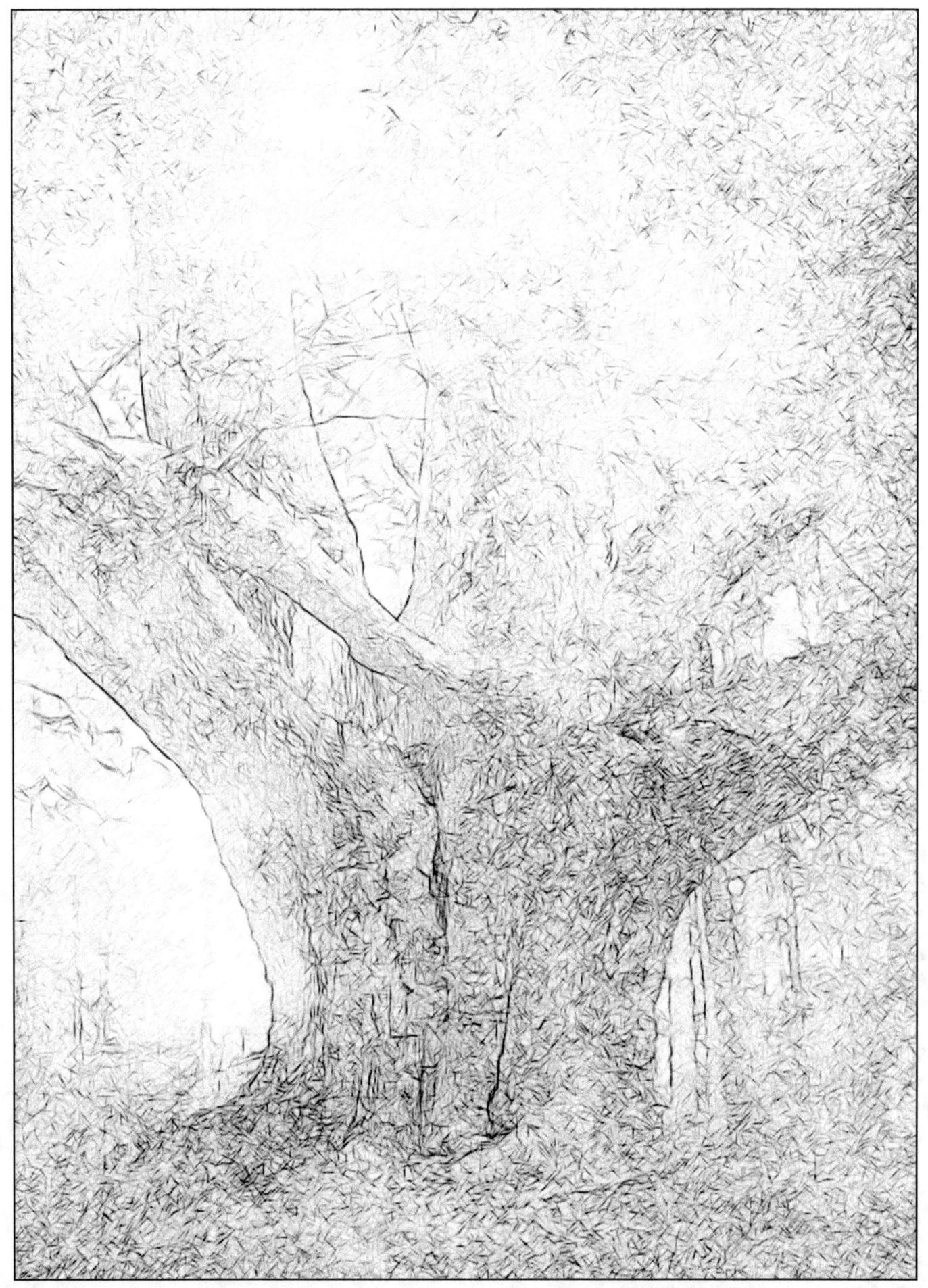

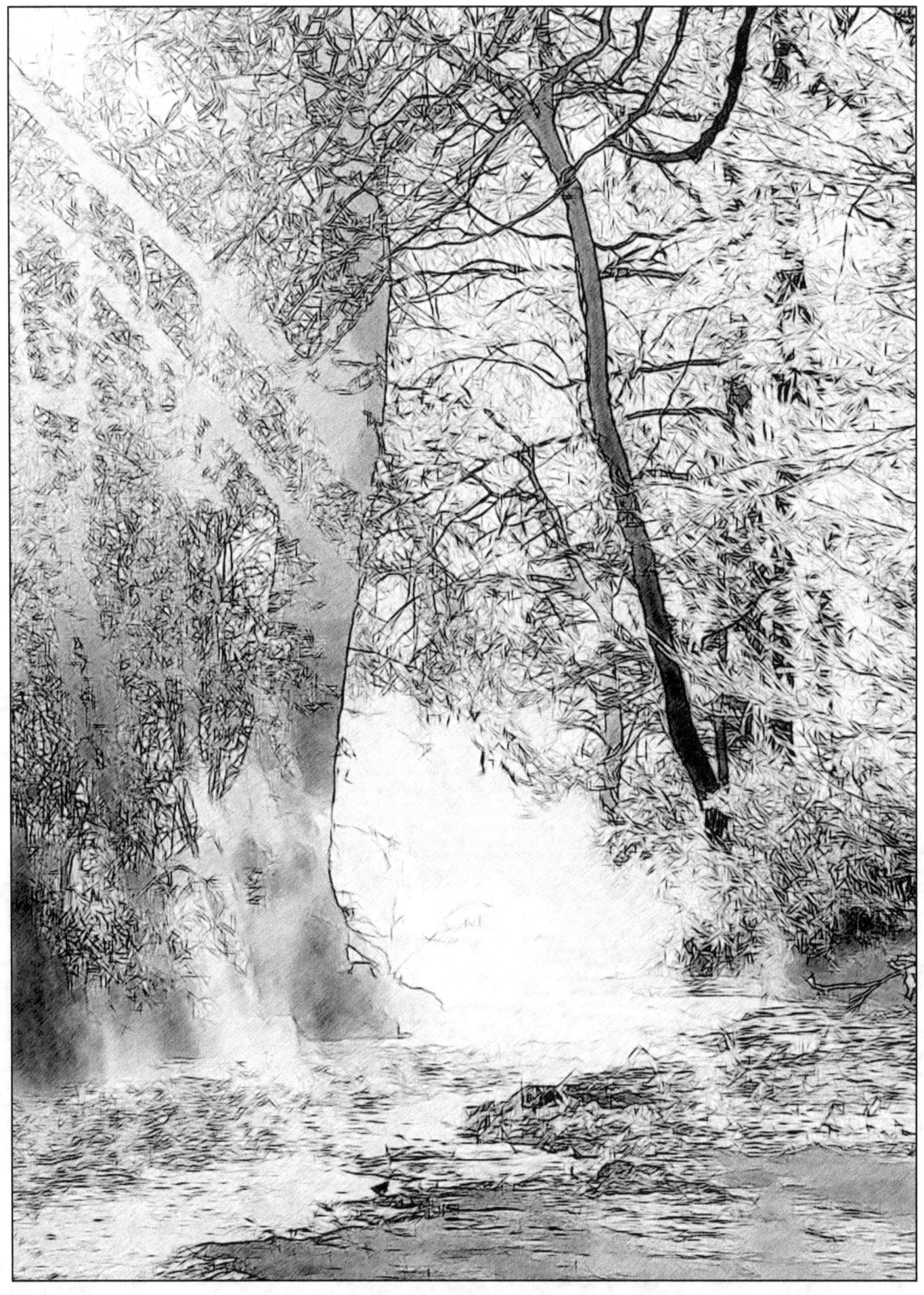

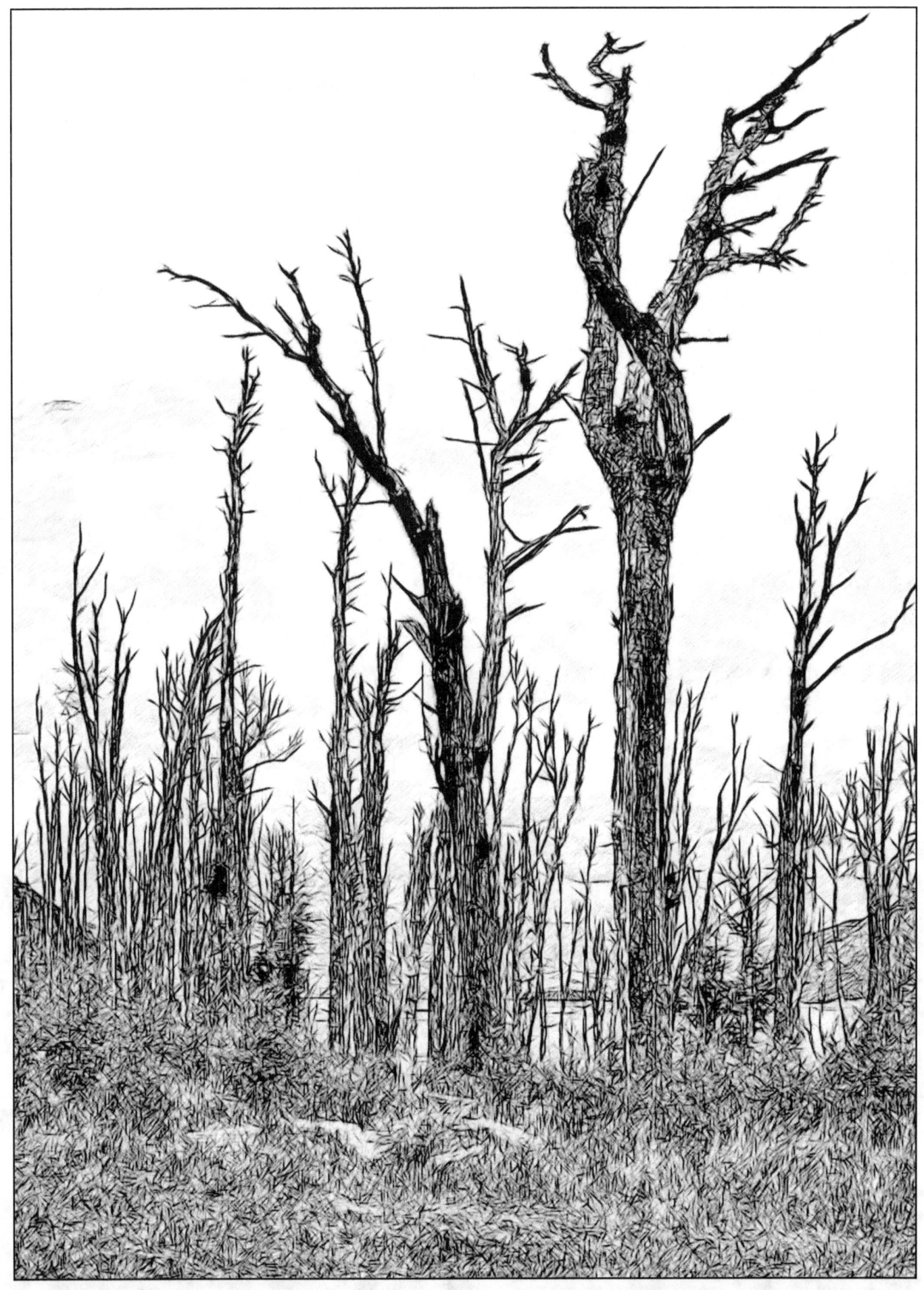

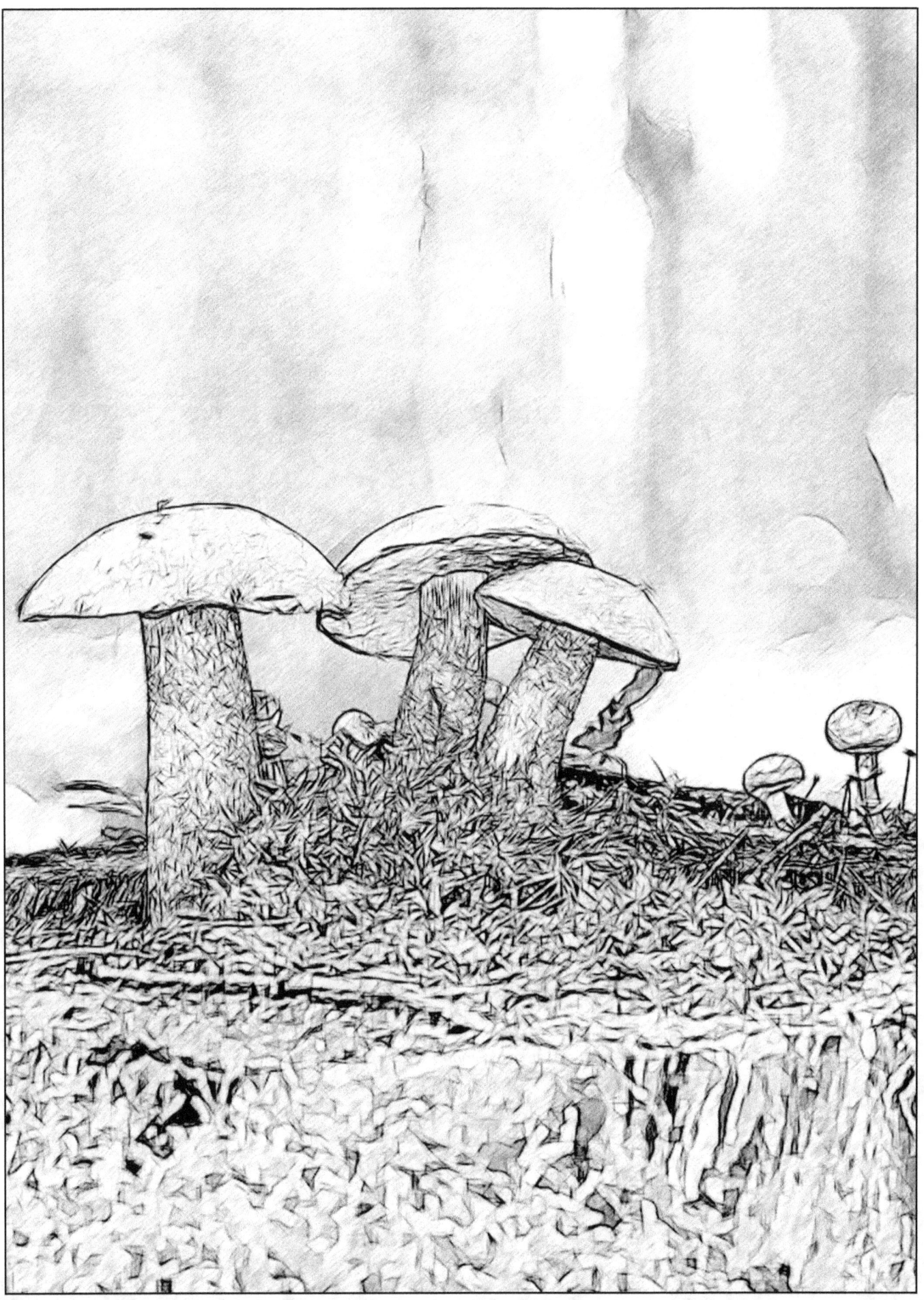

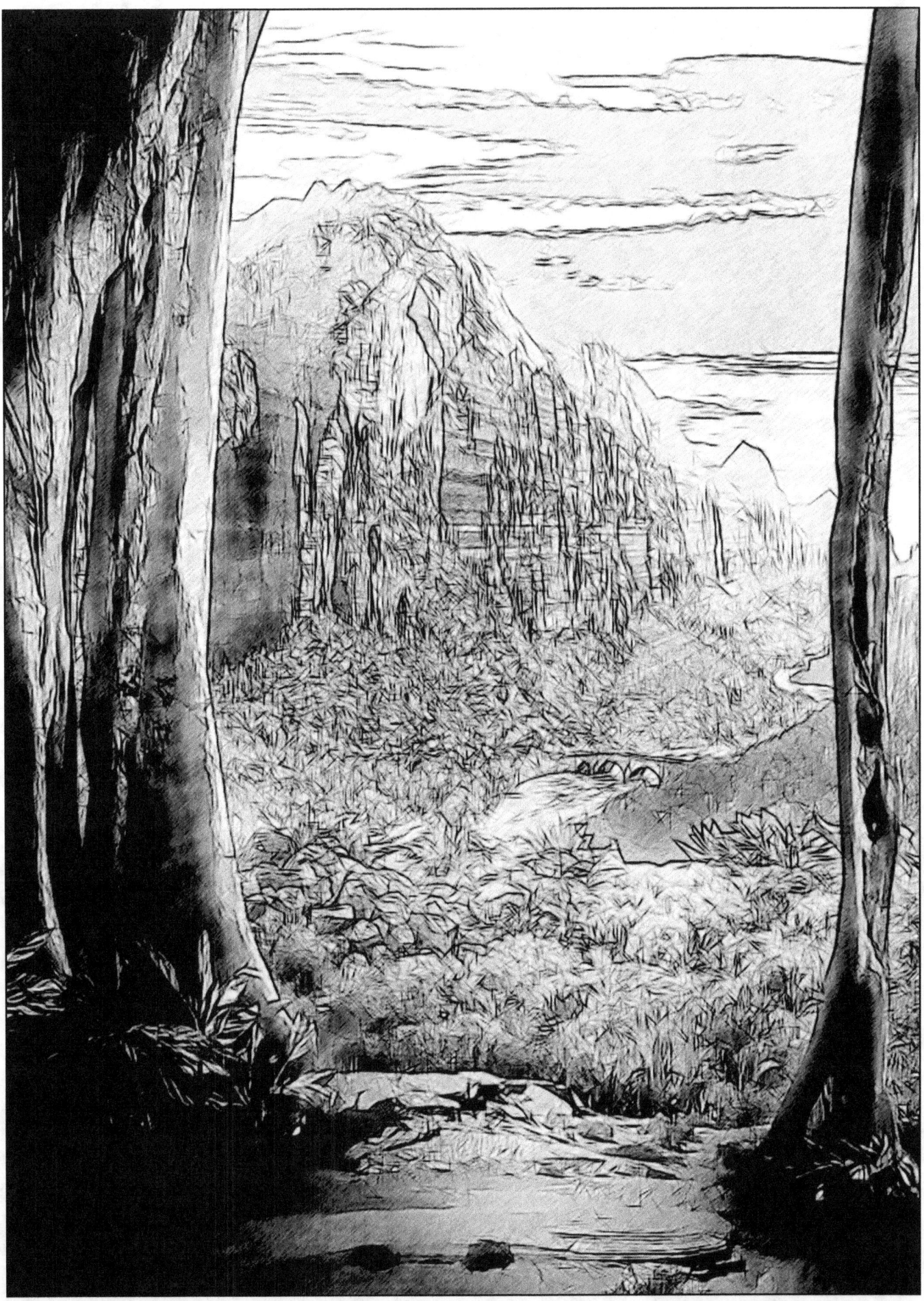

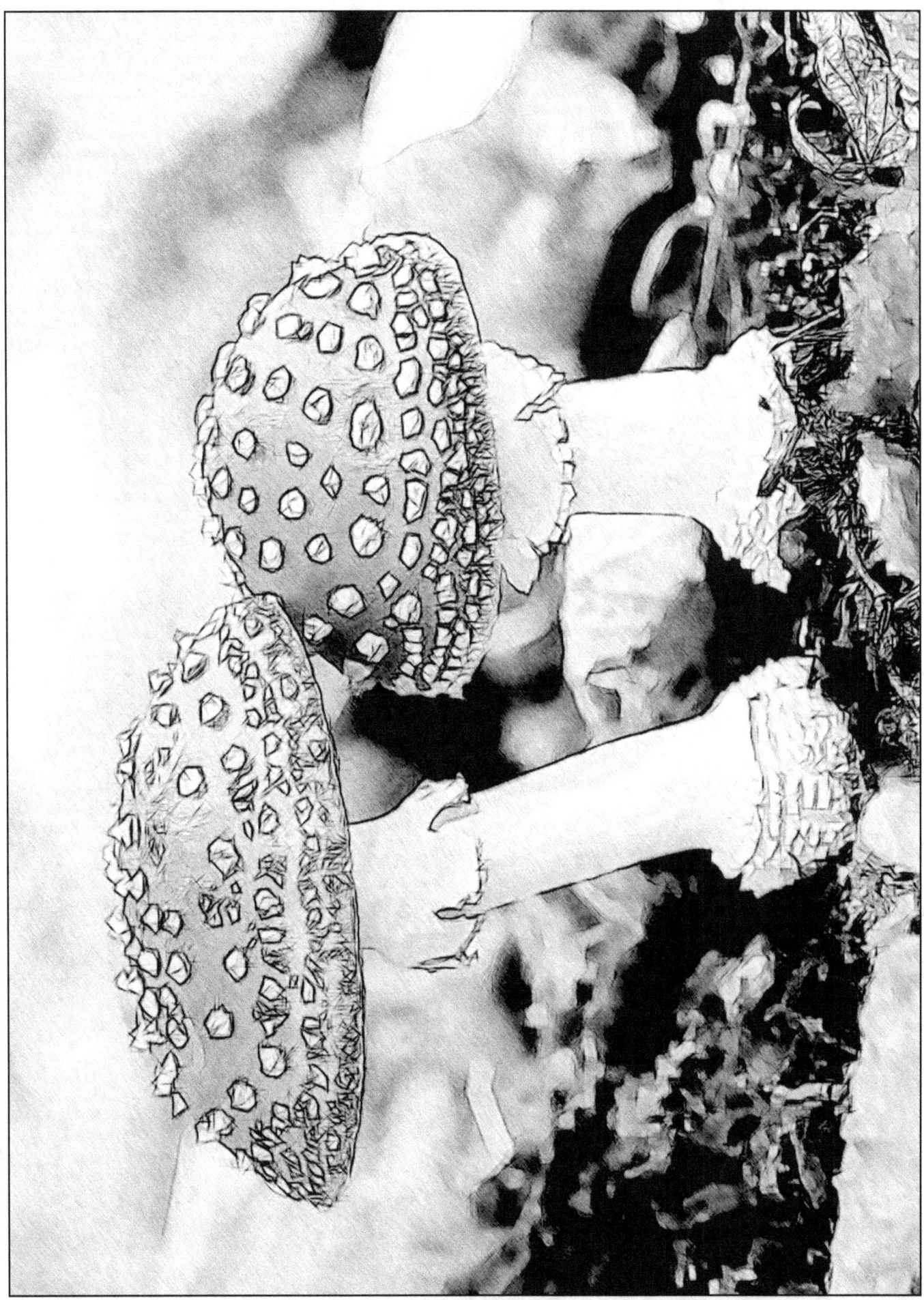

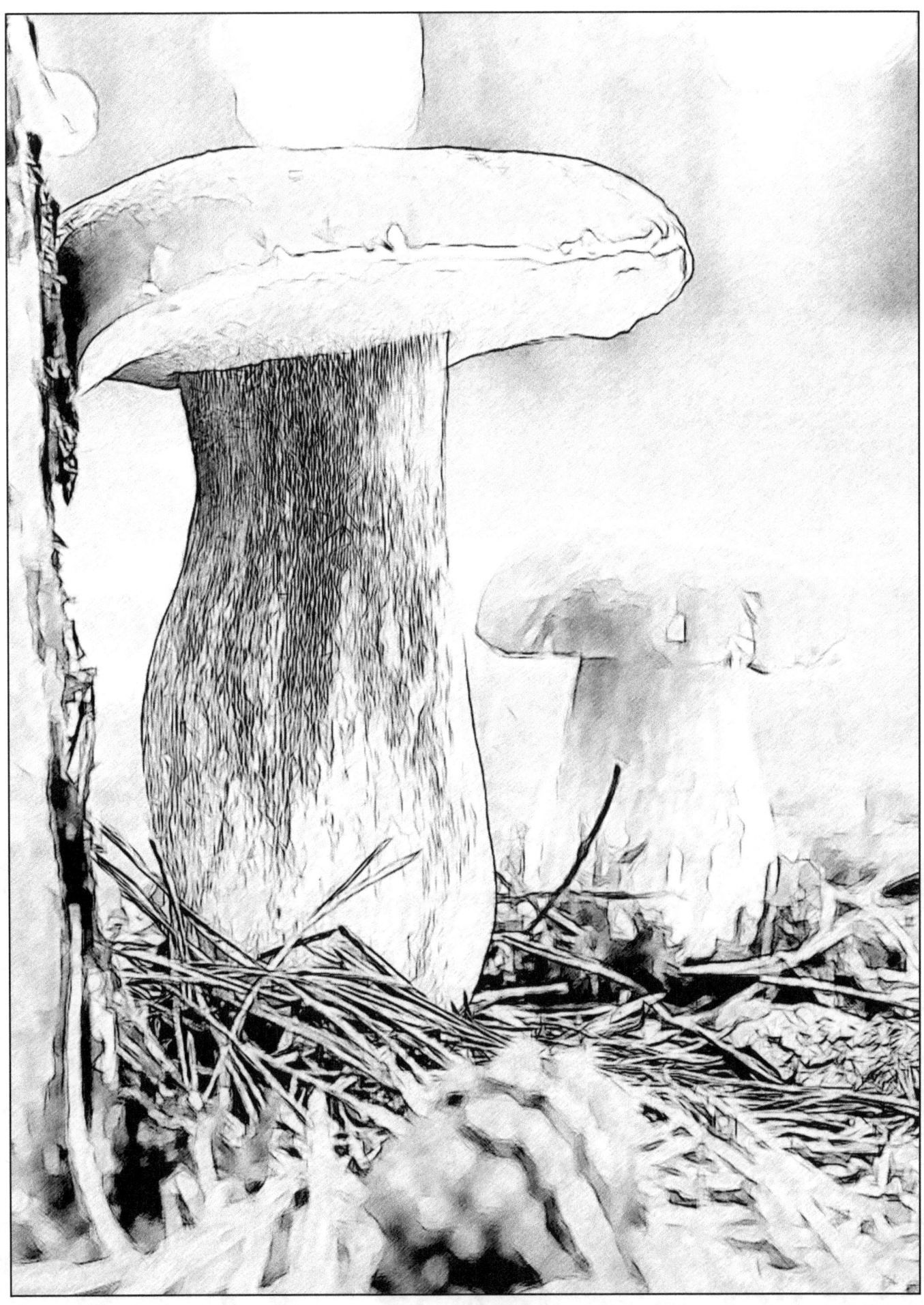

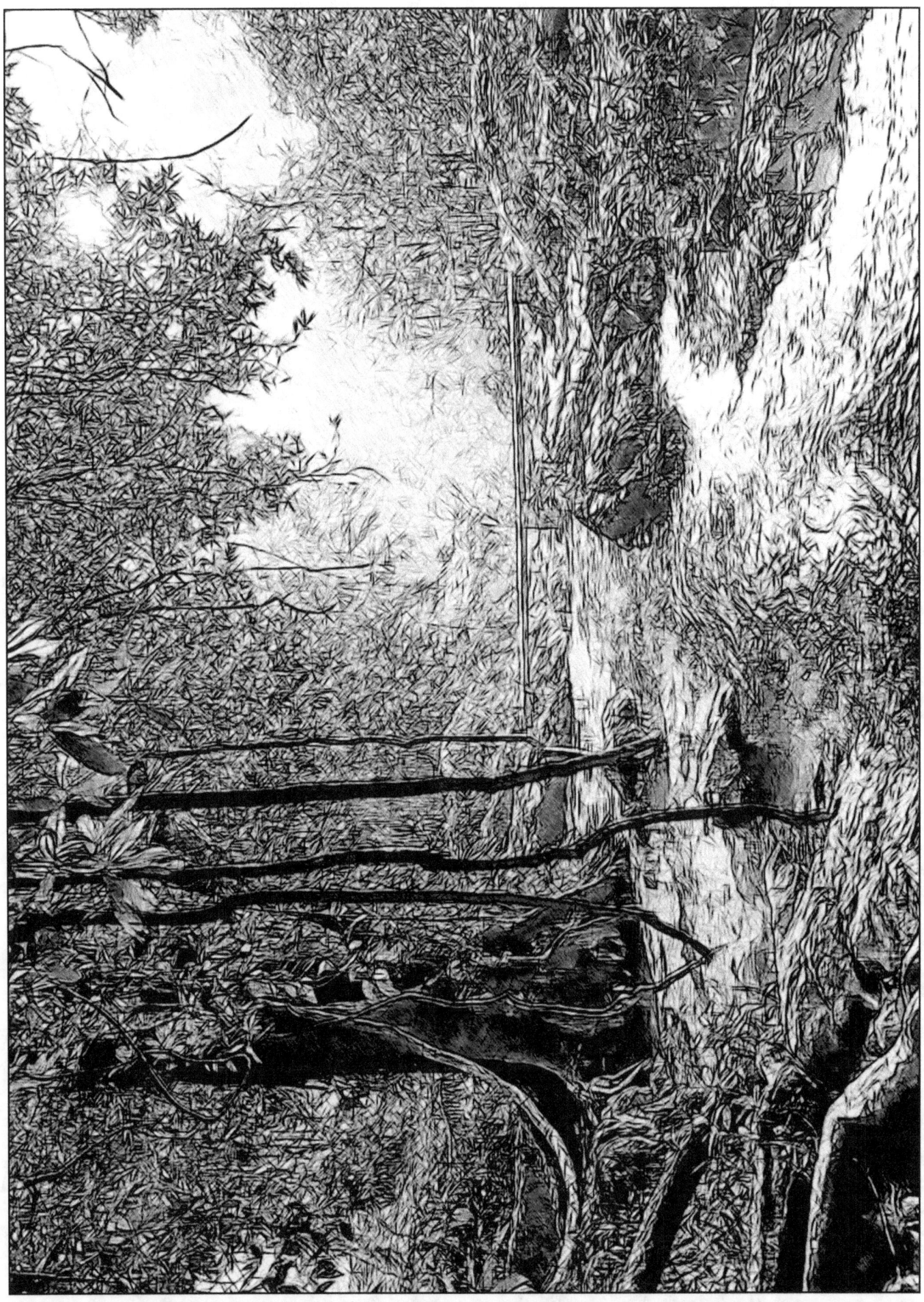

This is a Bleed Through Page If You Are Using a Coloring Marker or Pen!
Find Other Great Titles By searching for <u>Coloring Therapists</u> on Your Favorite Book Retailer
Amazon.Com | Barnes & Noble (BN.Com) | Books A Million (BAM.Com)

Coloring Therapists
STRESS RELIEVING COLORING ACTIVITIES

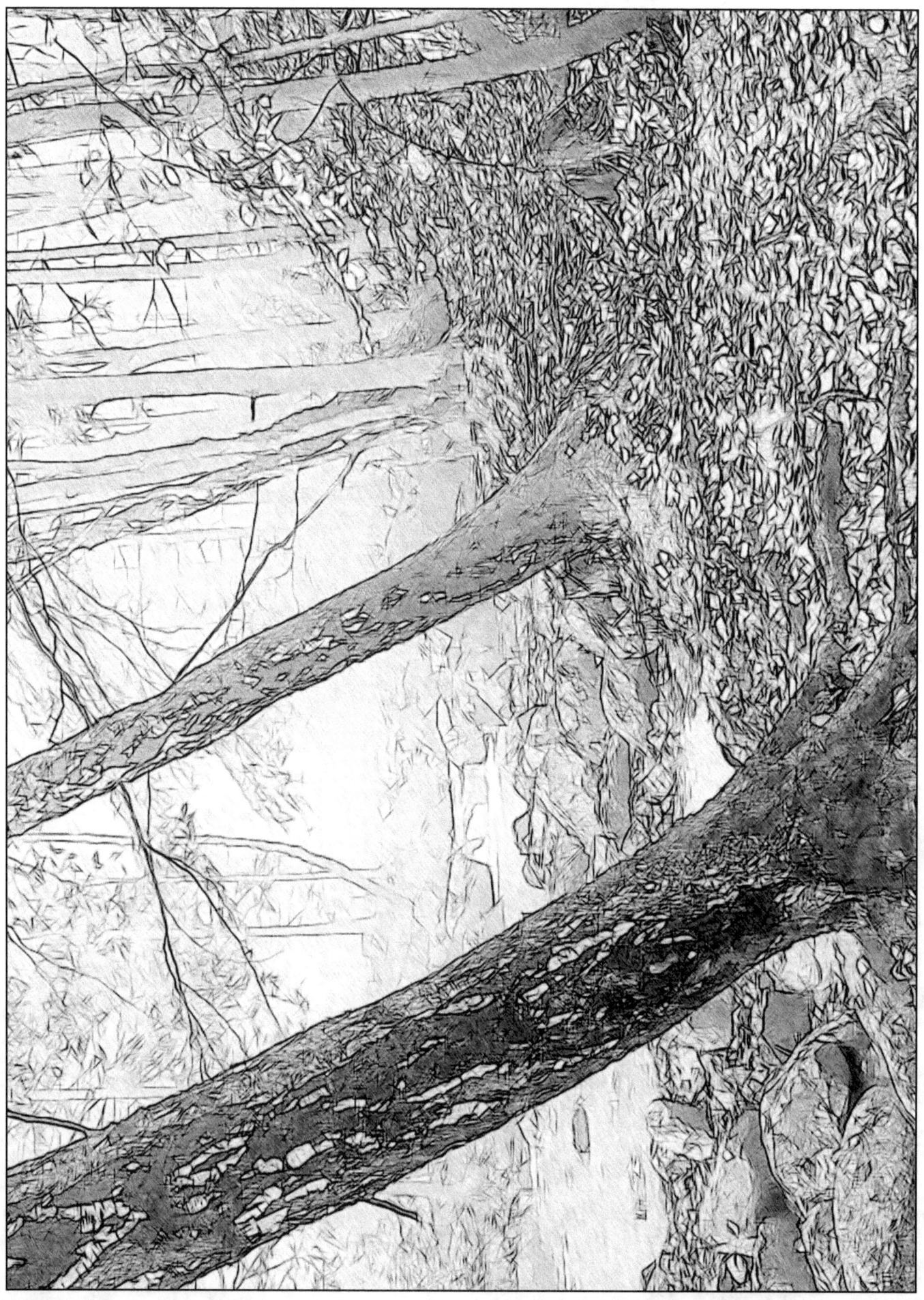

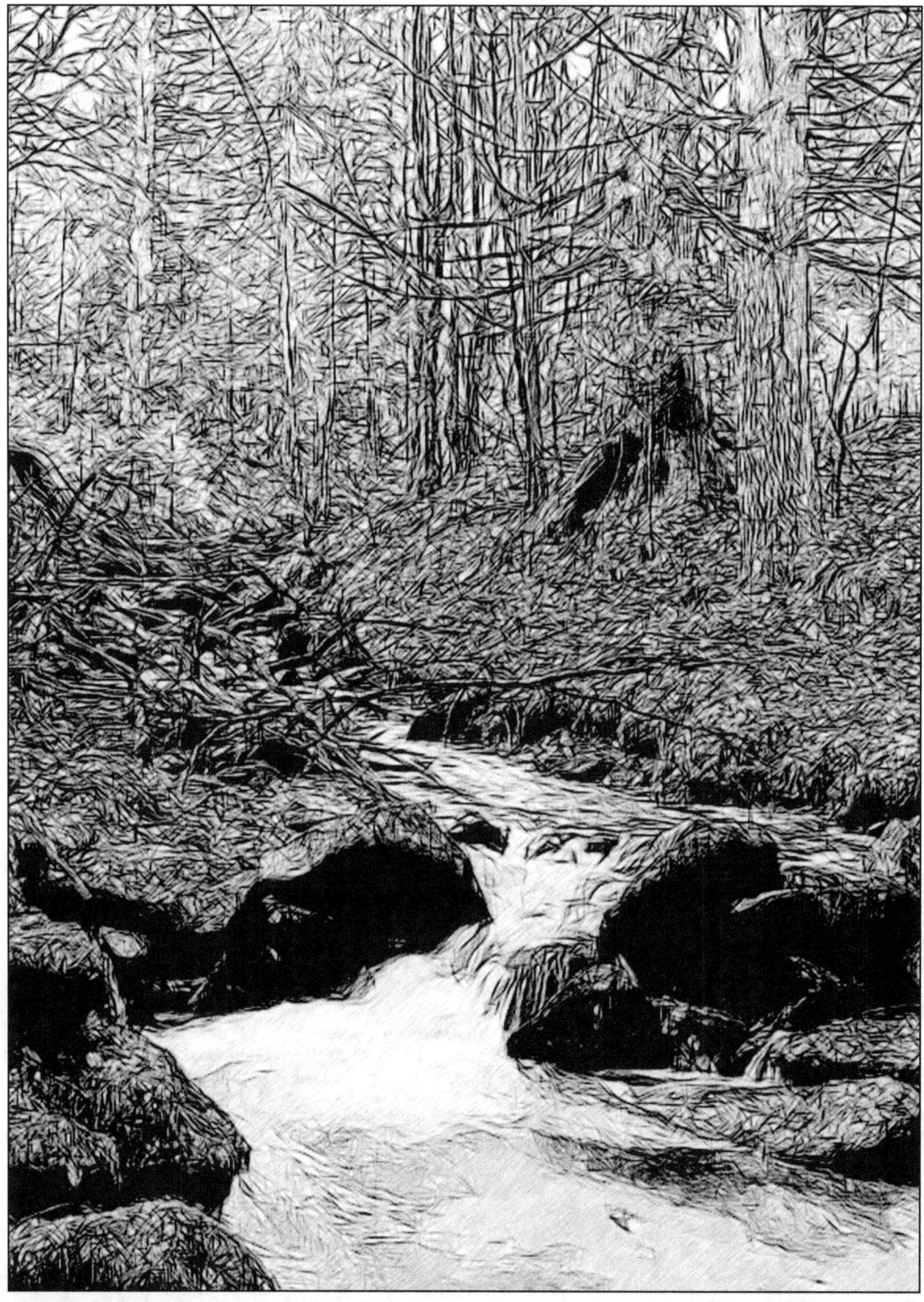

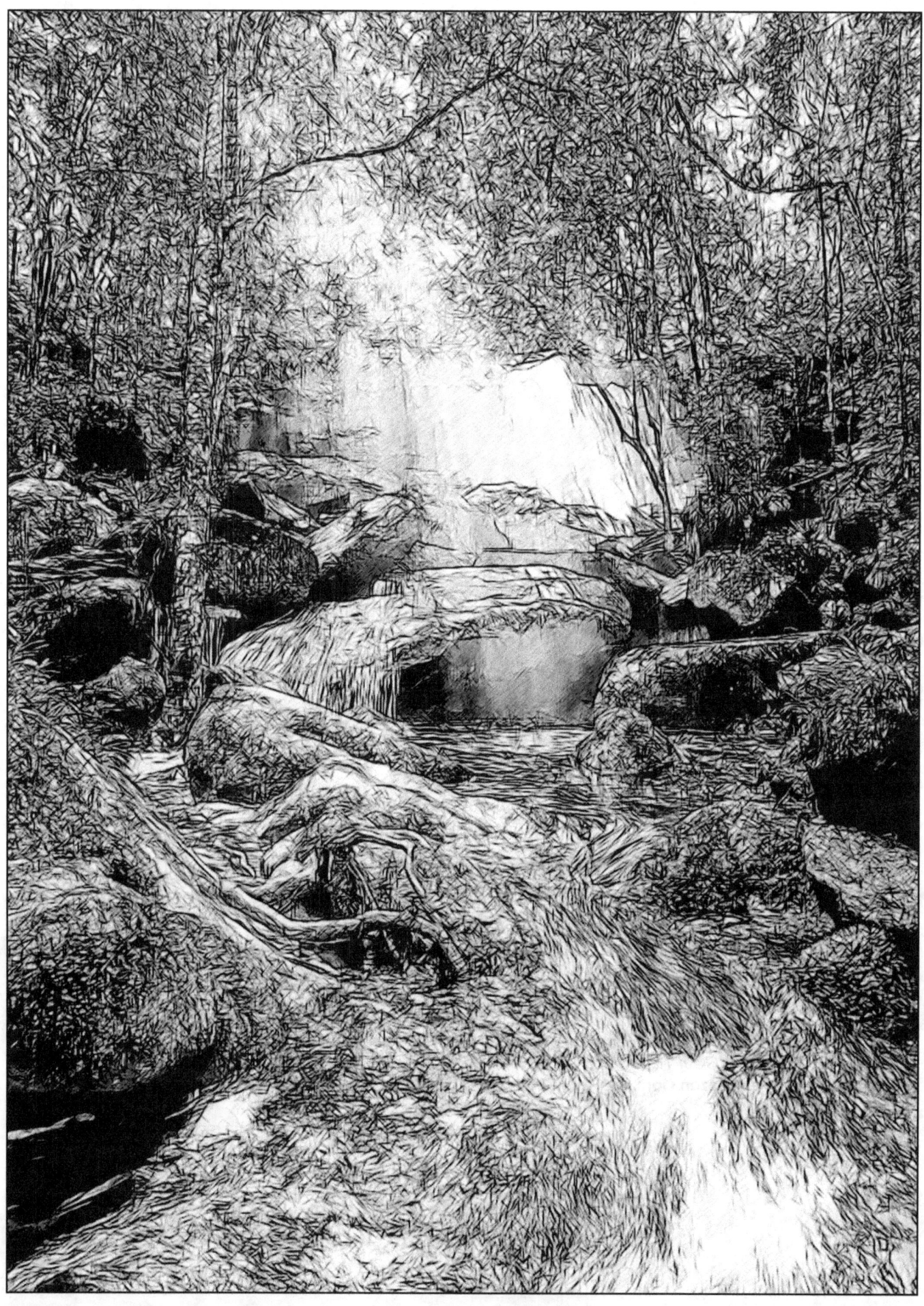

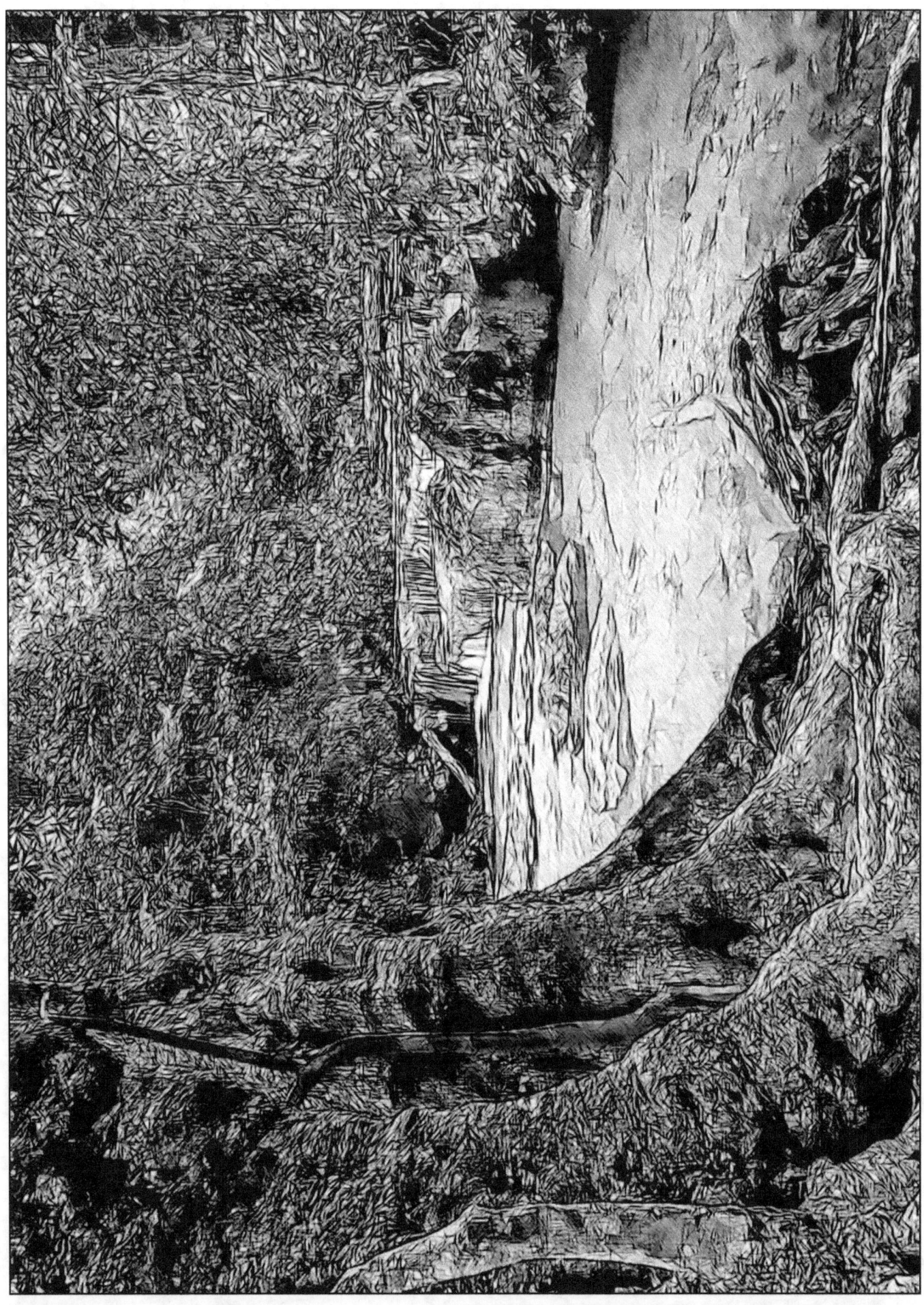

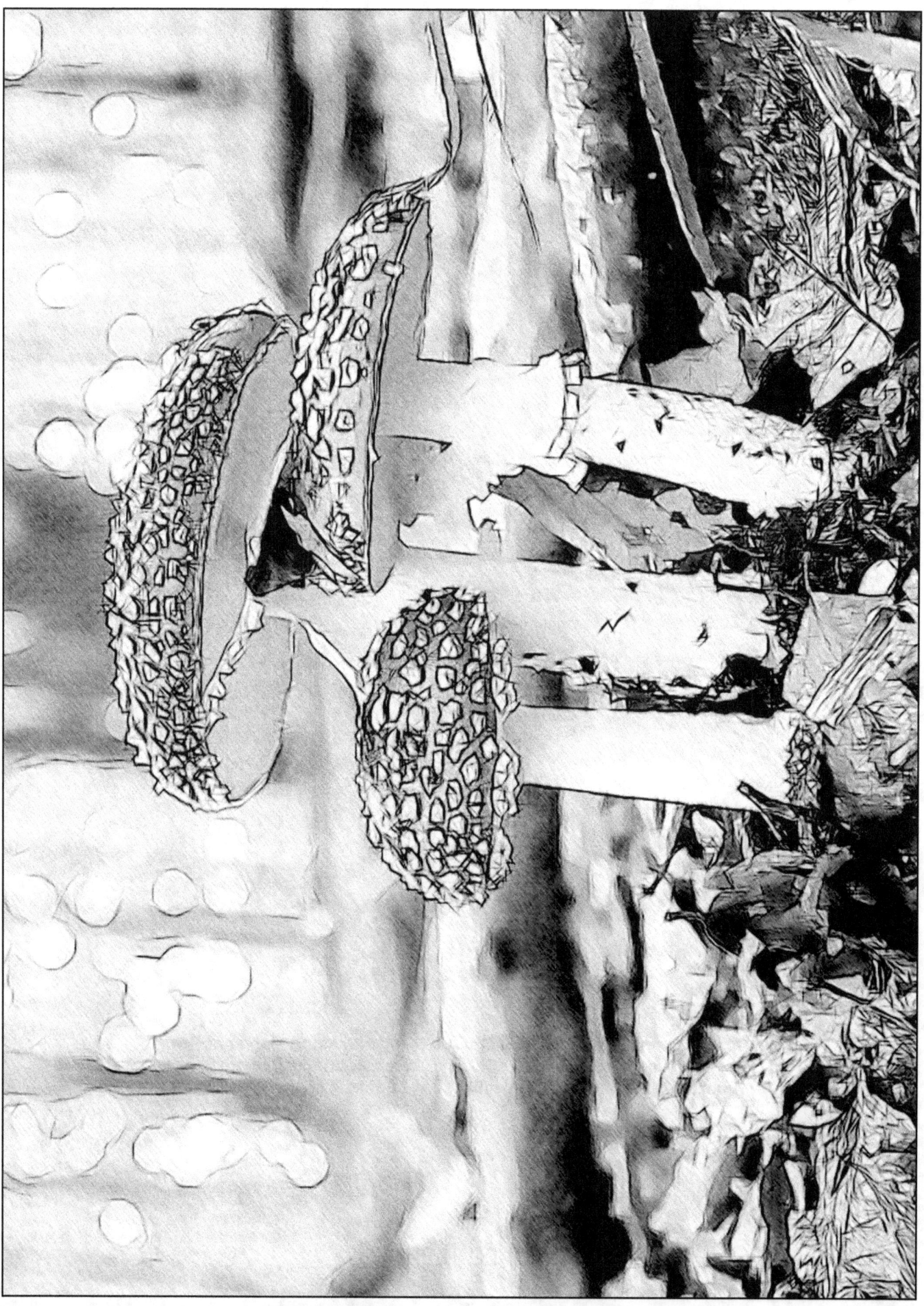

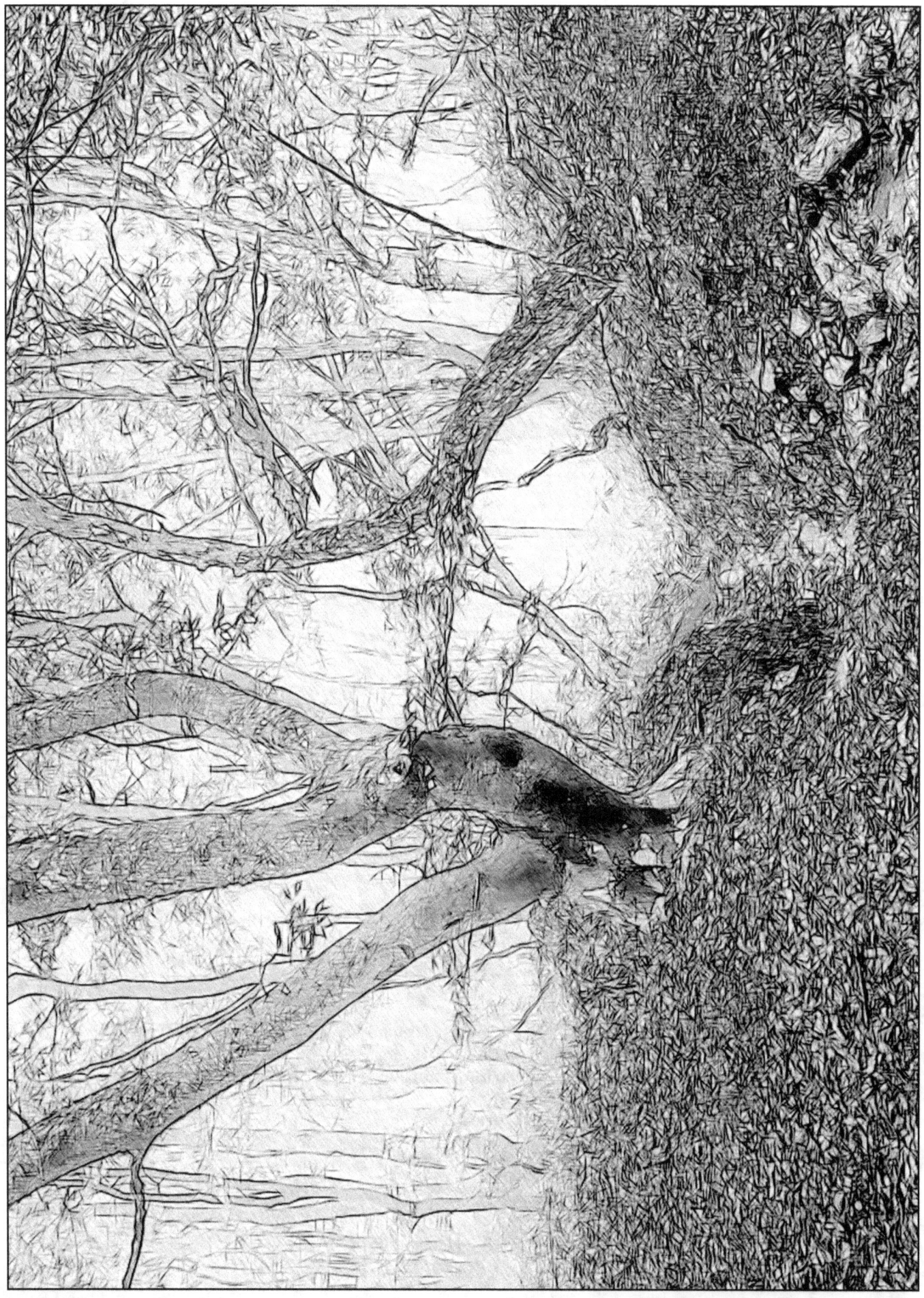

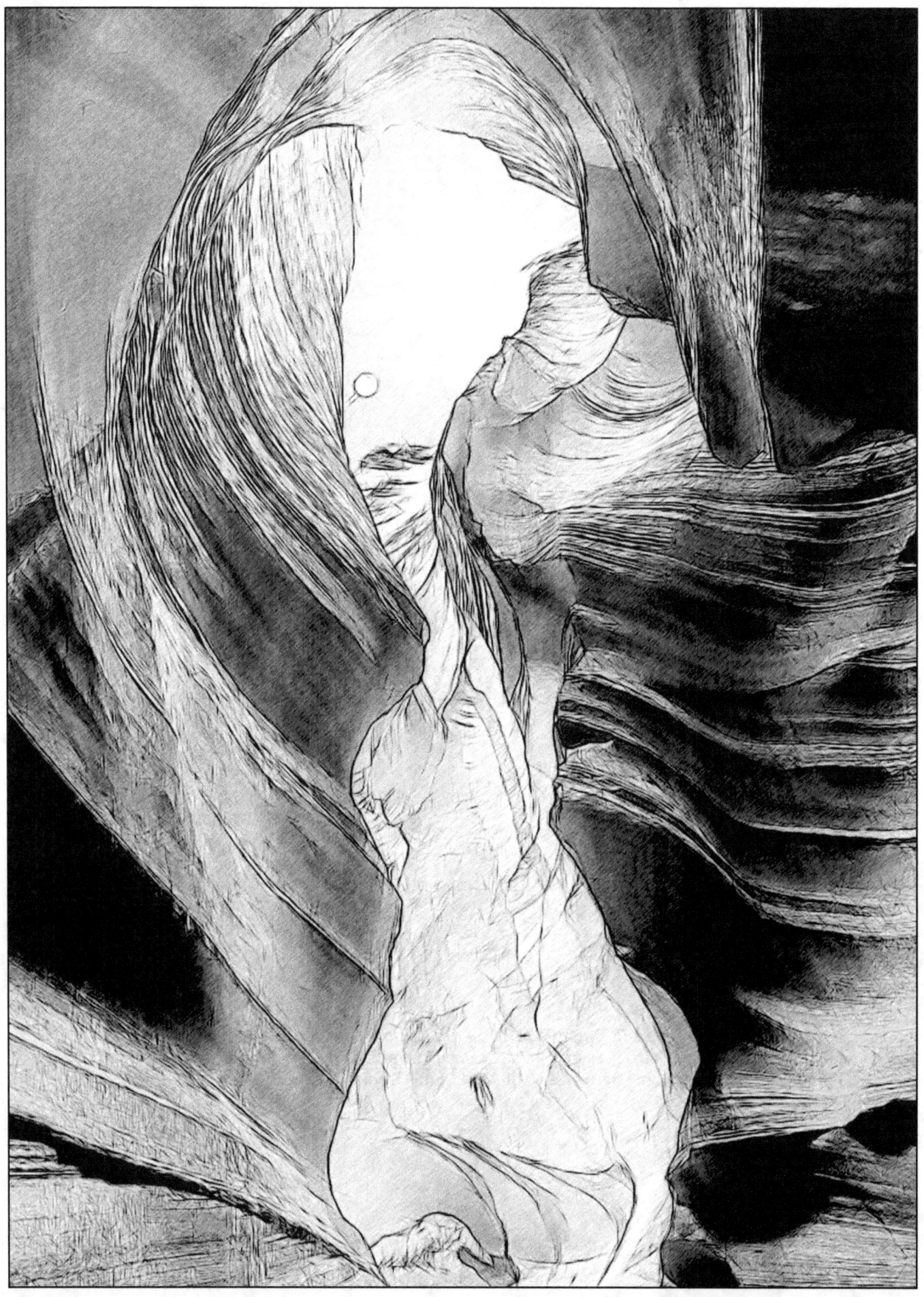

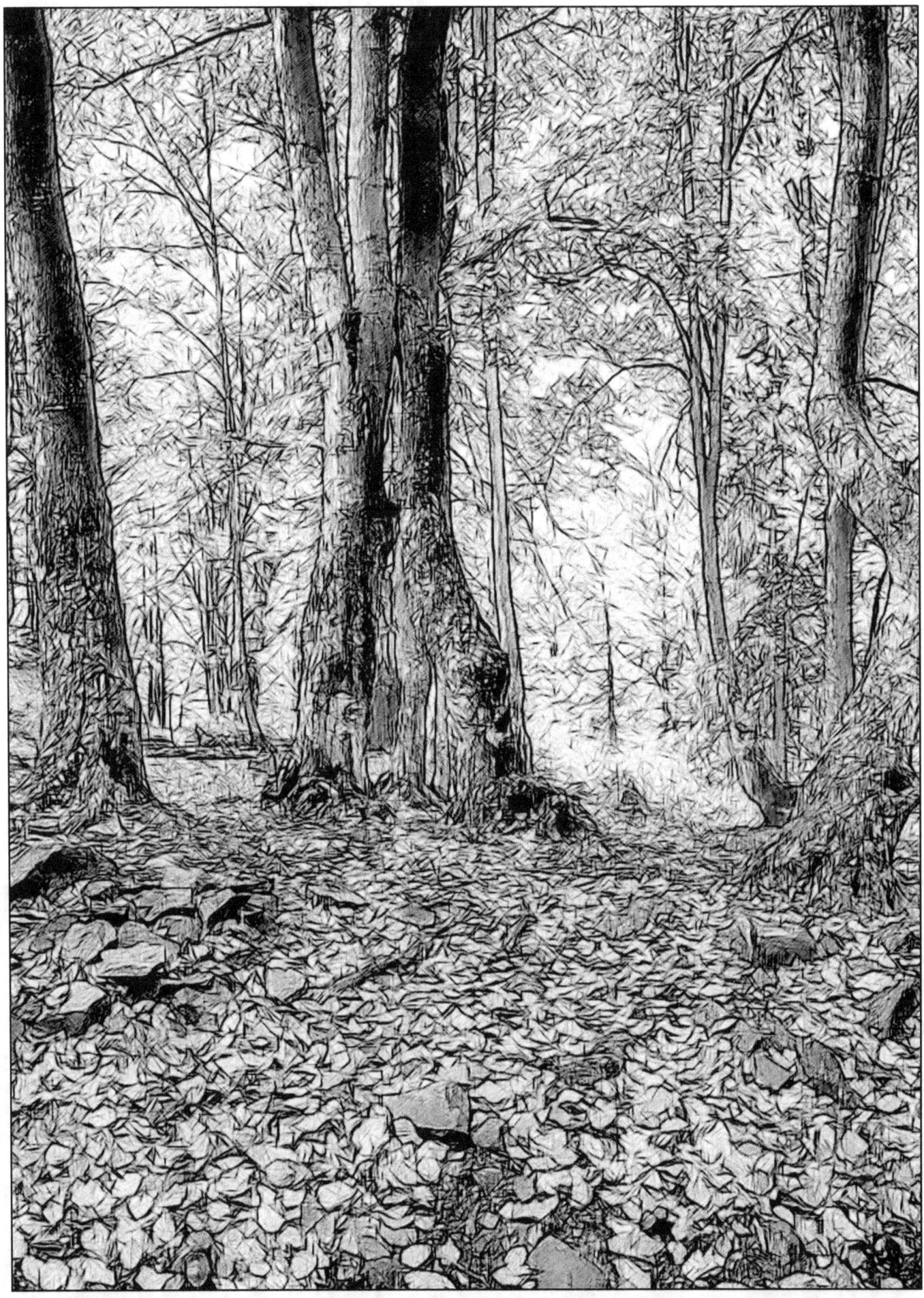

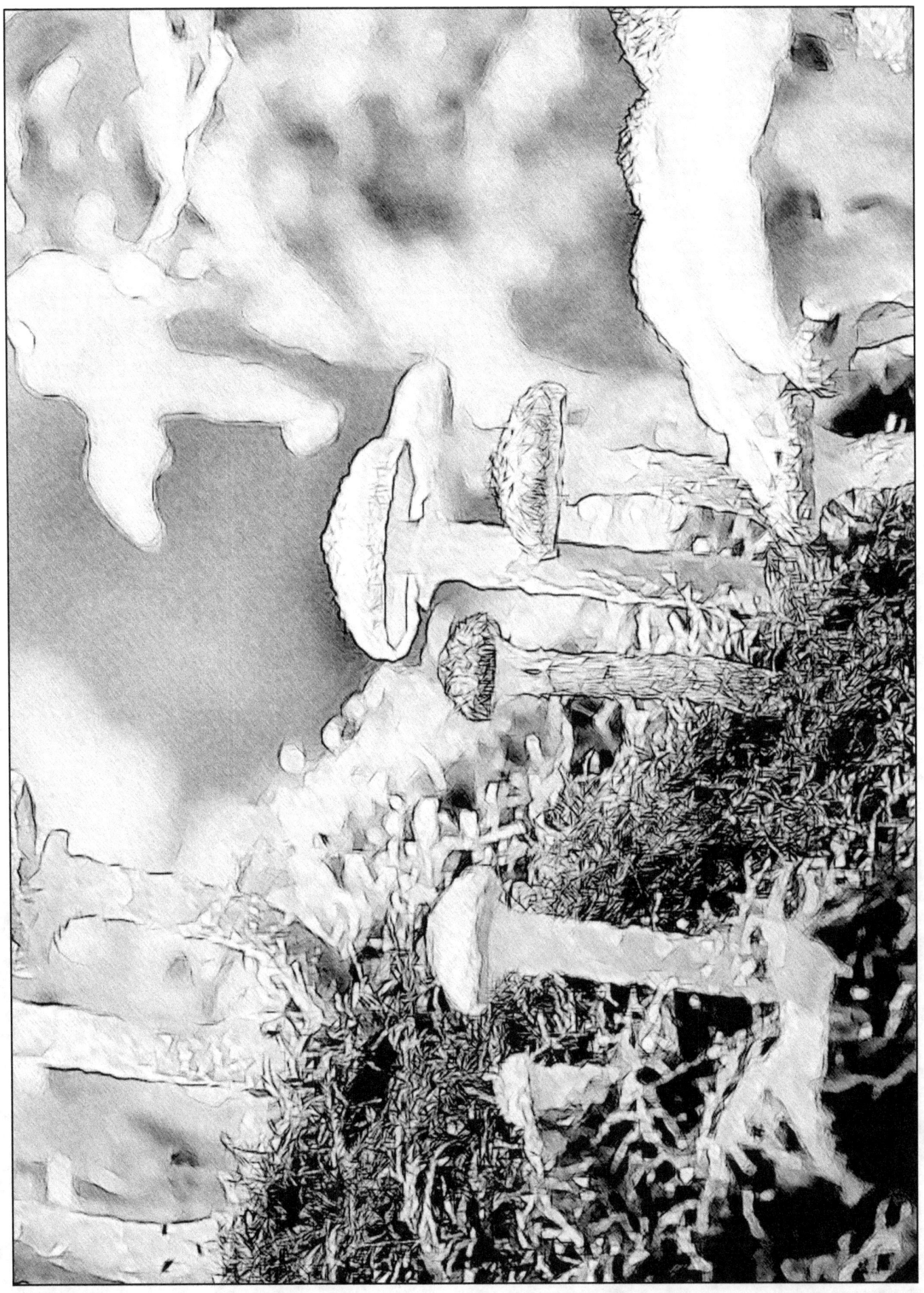

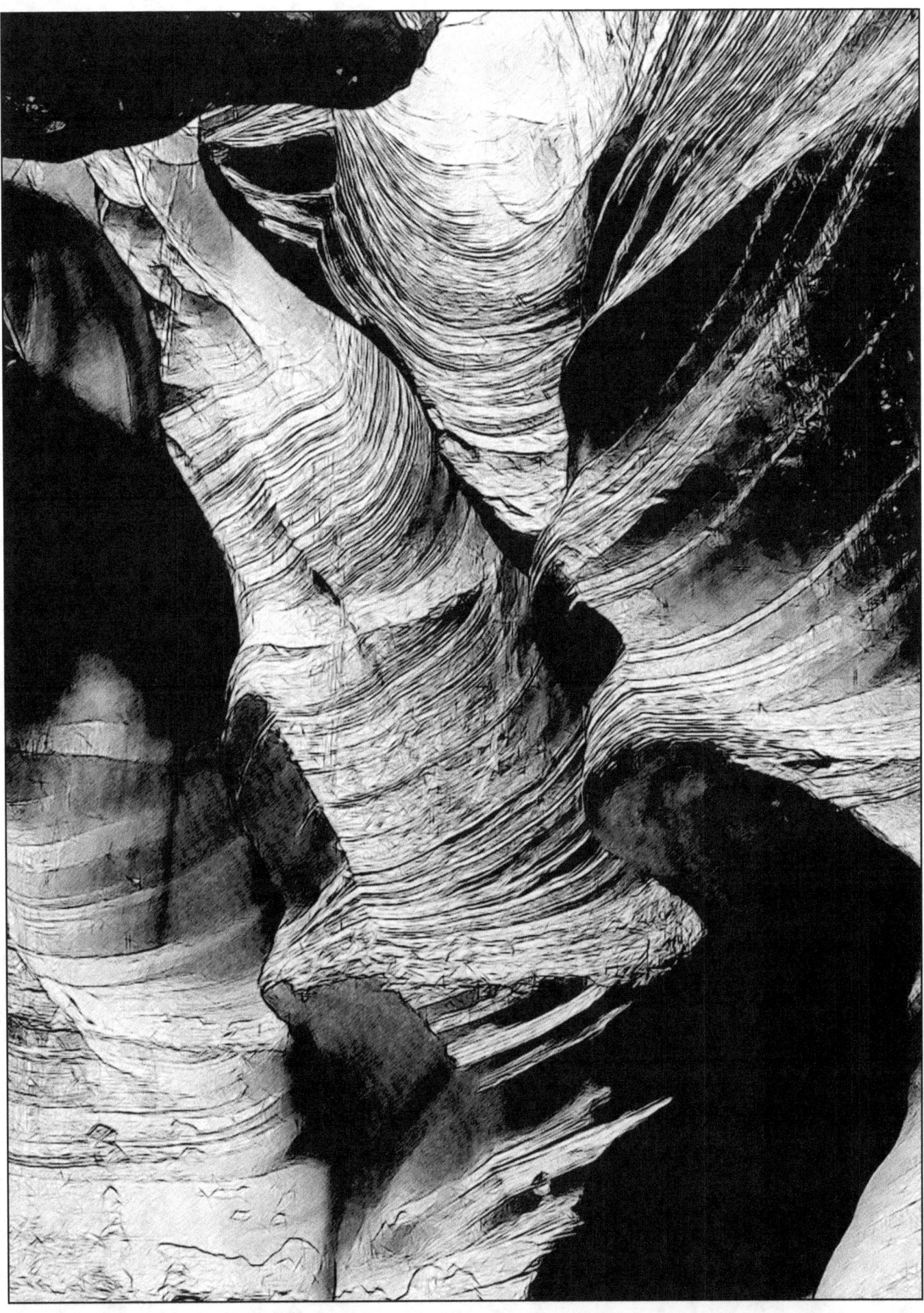

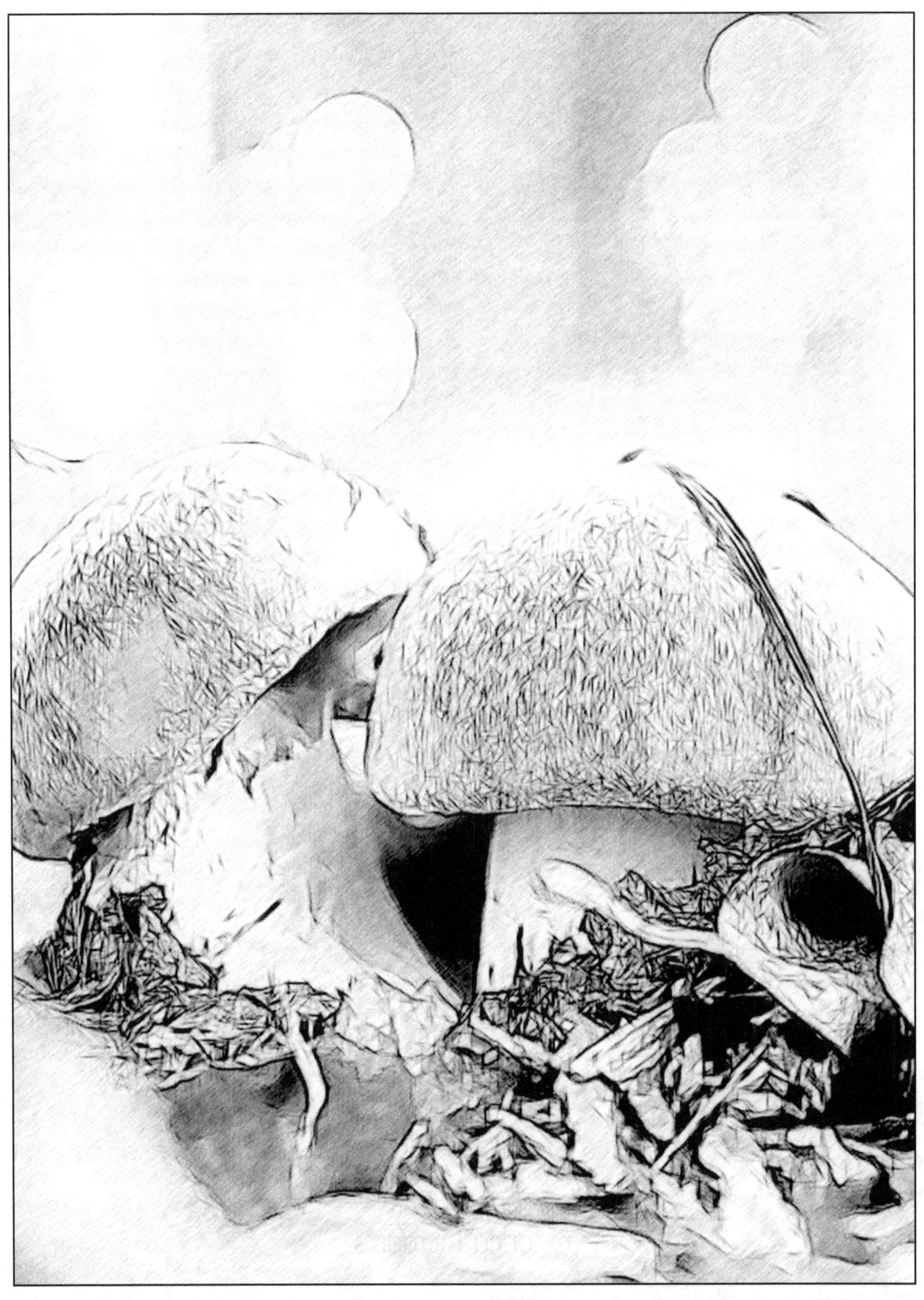

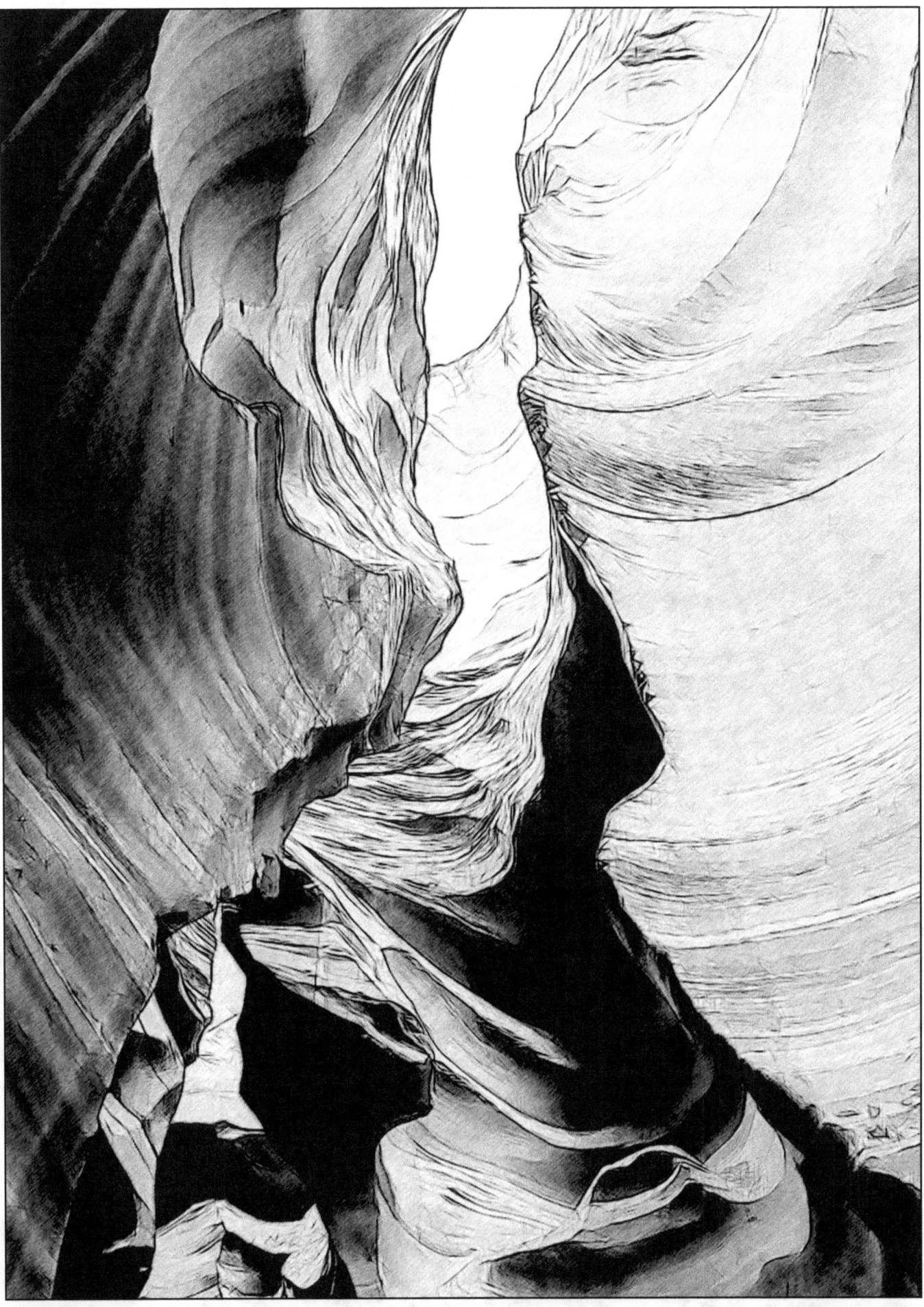

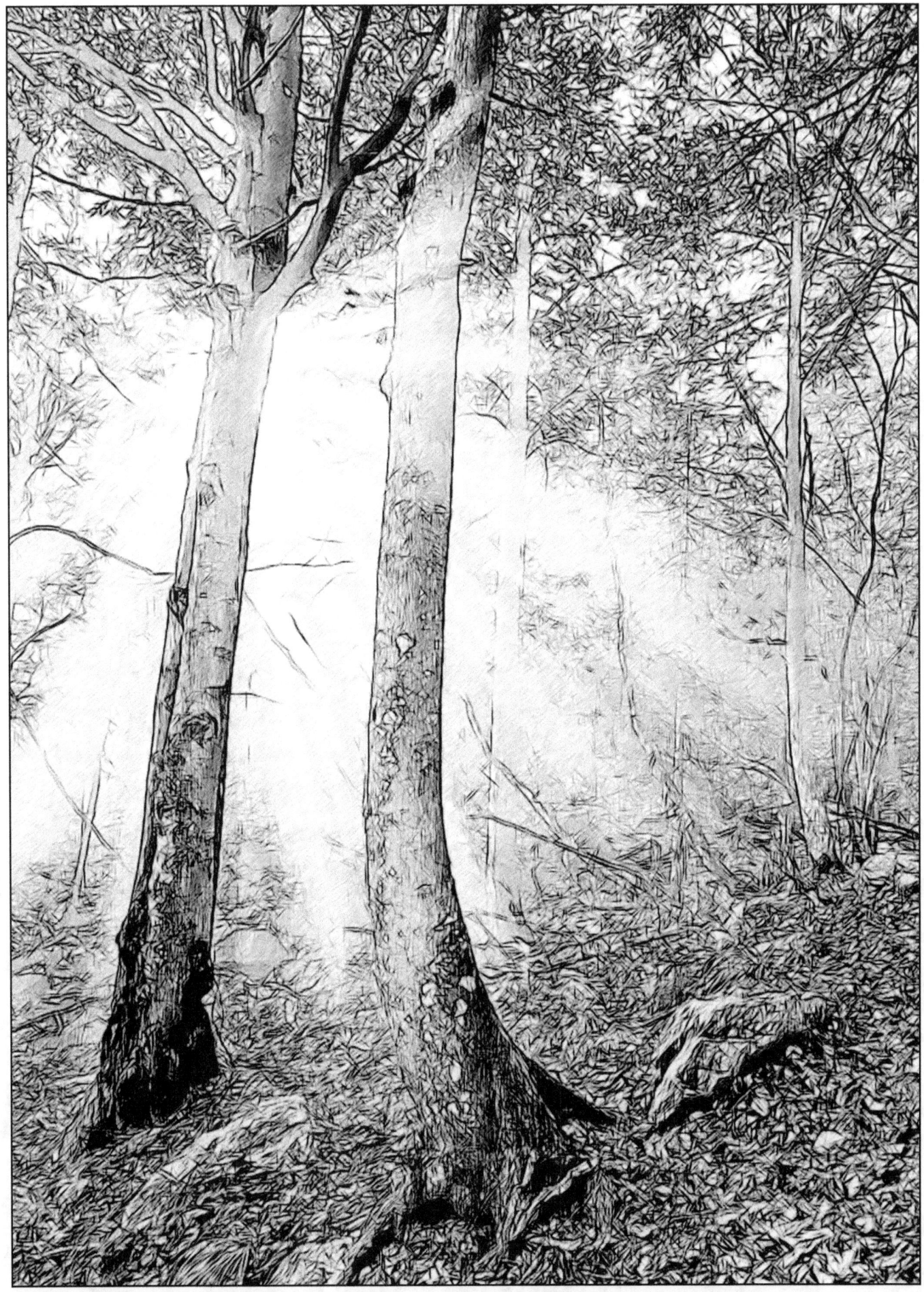

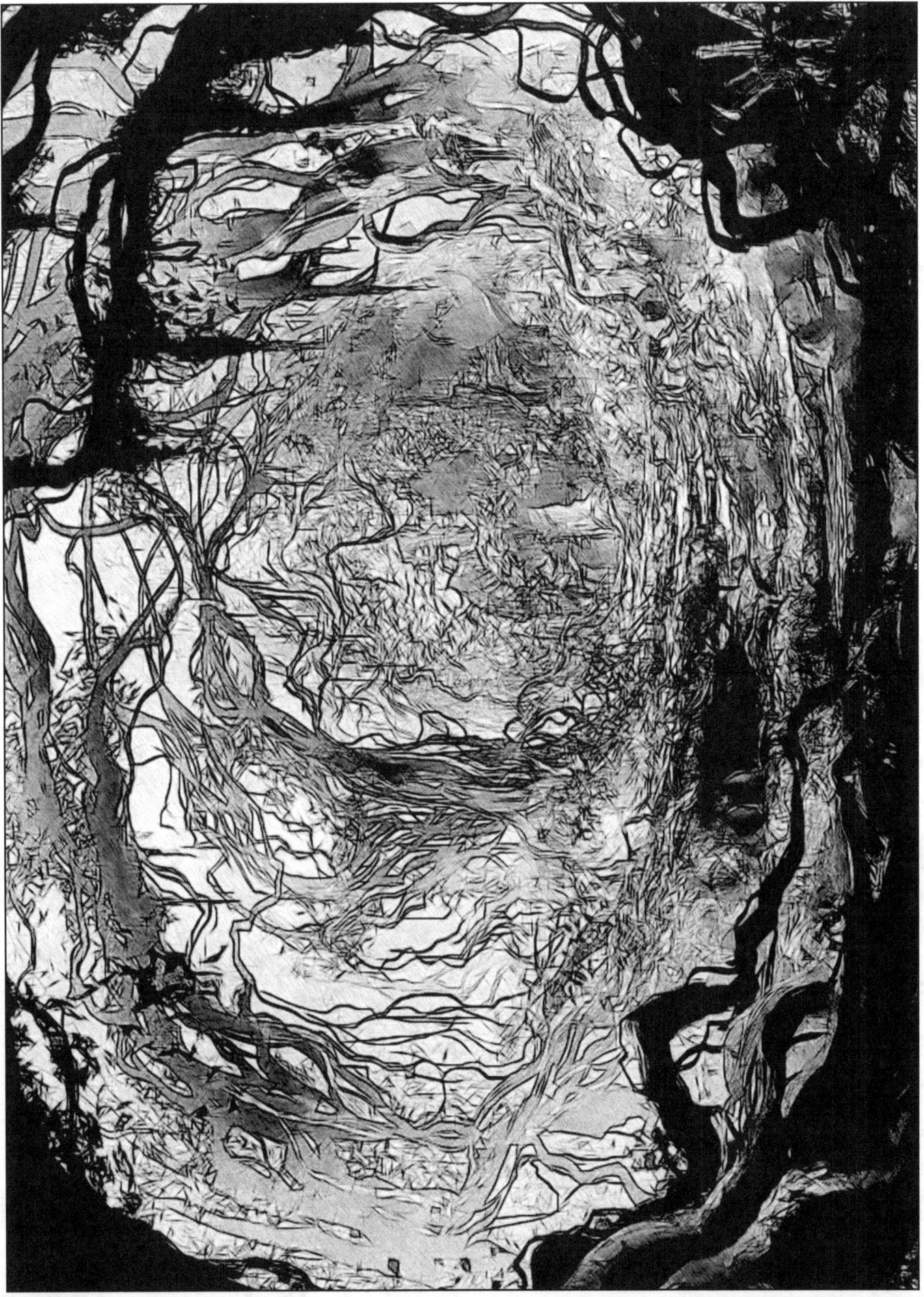

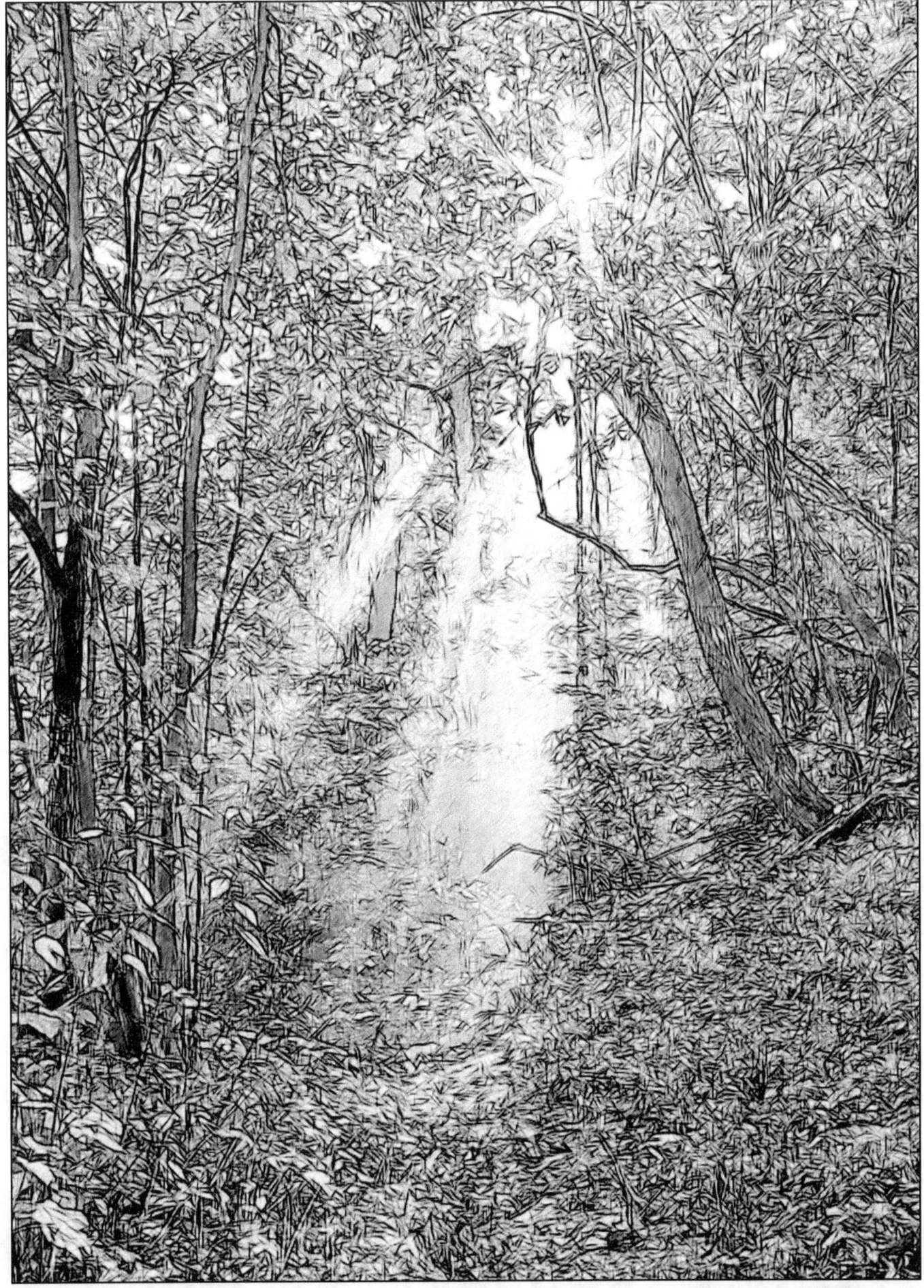

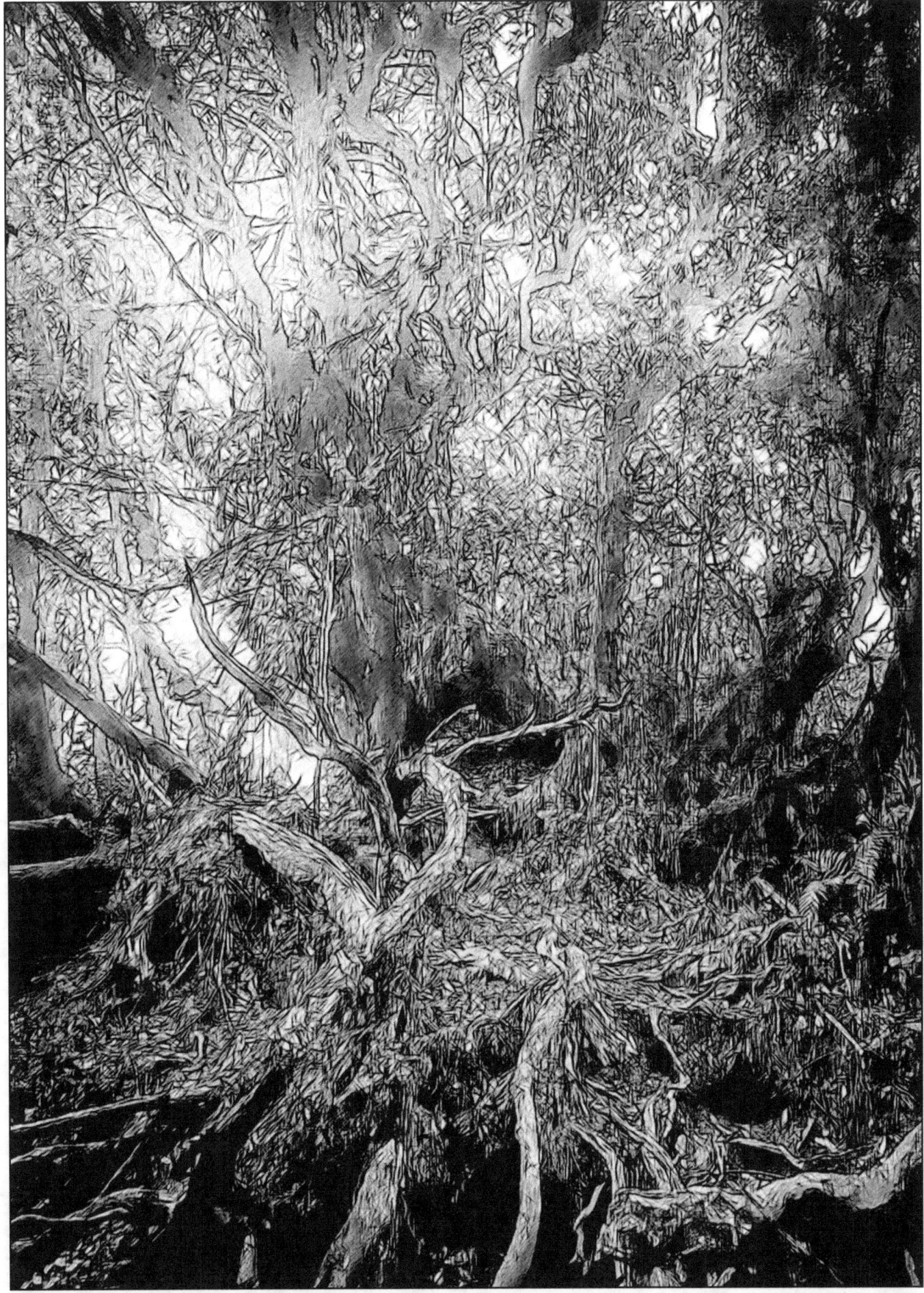

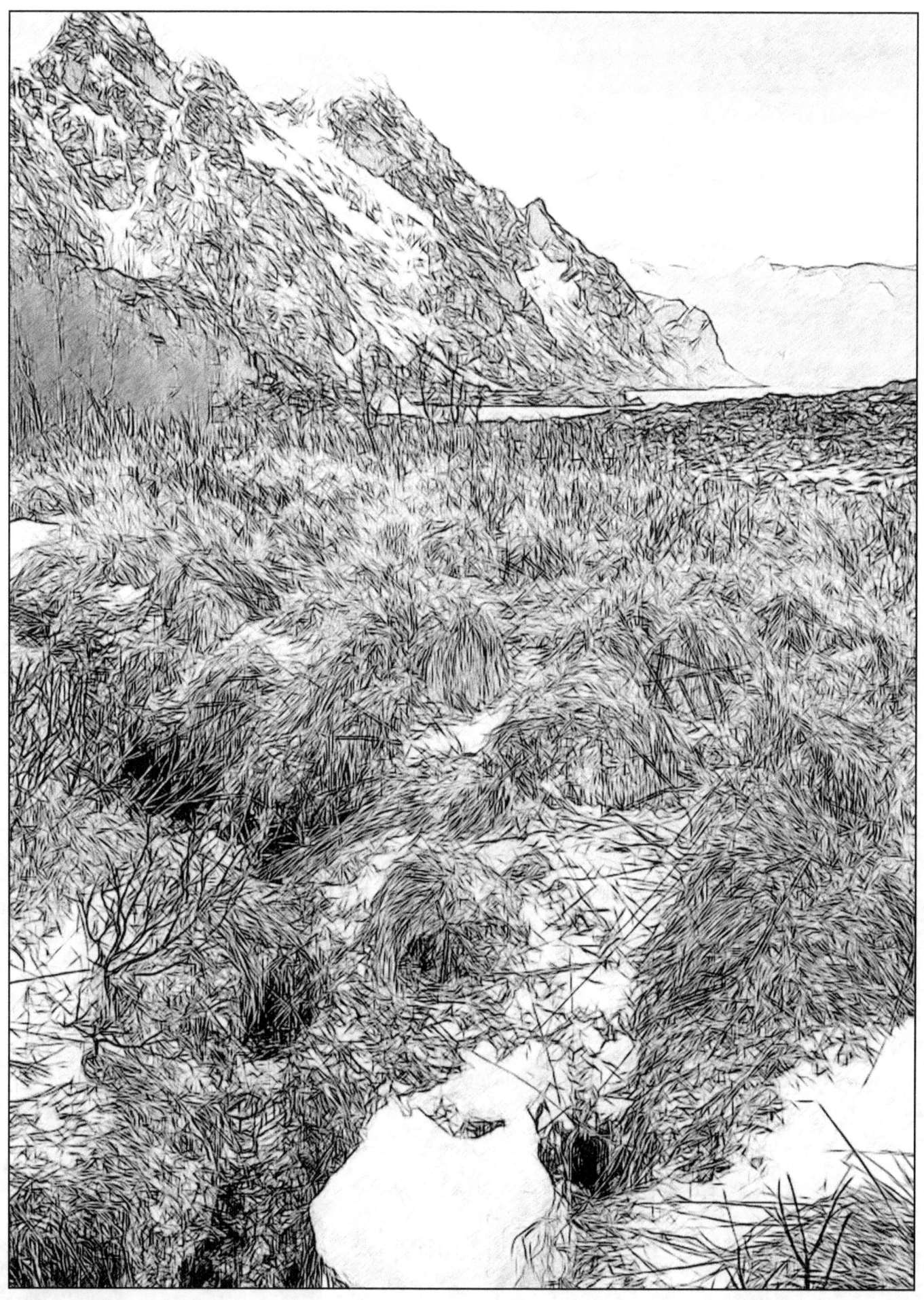

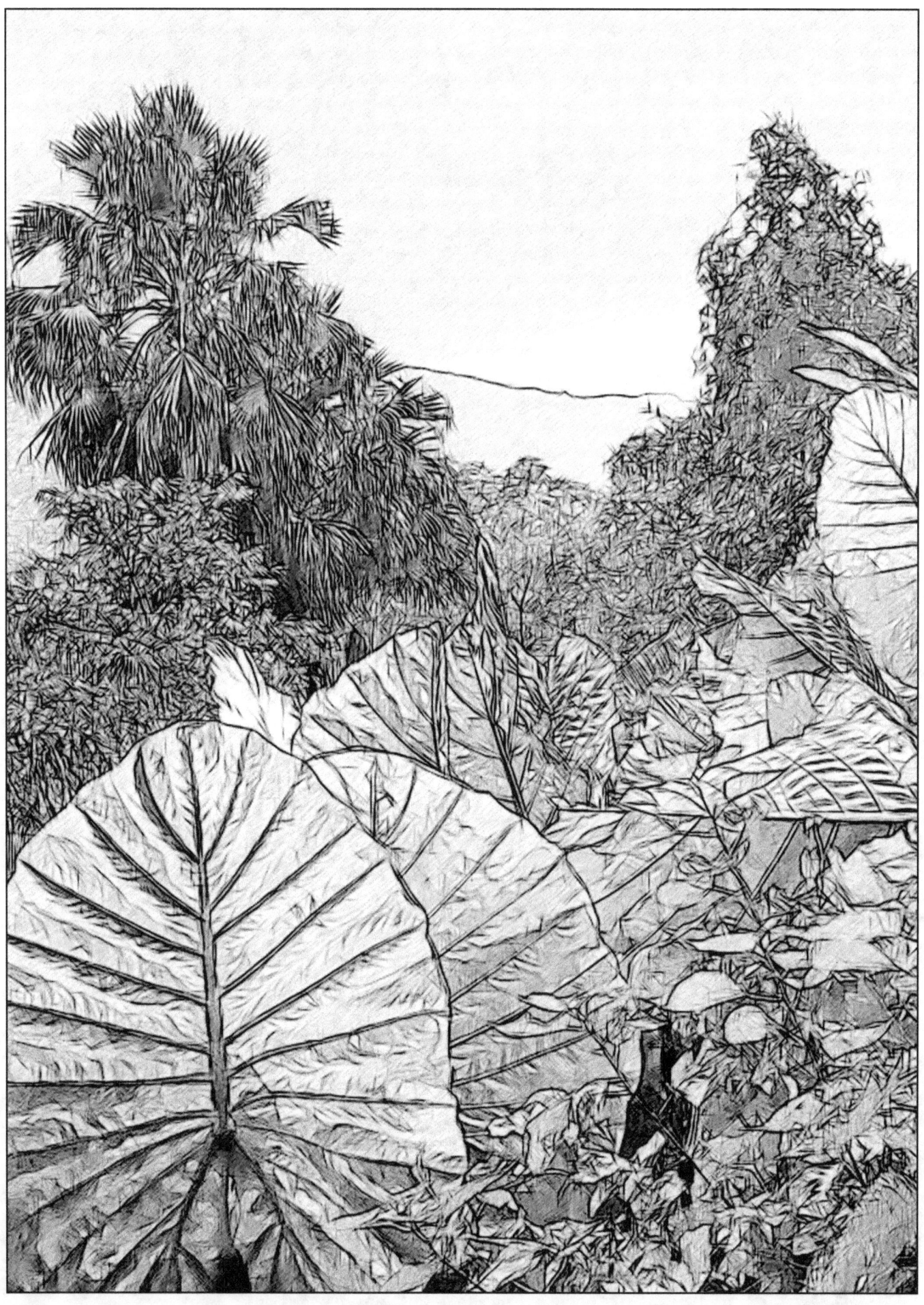

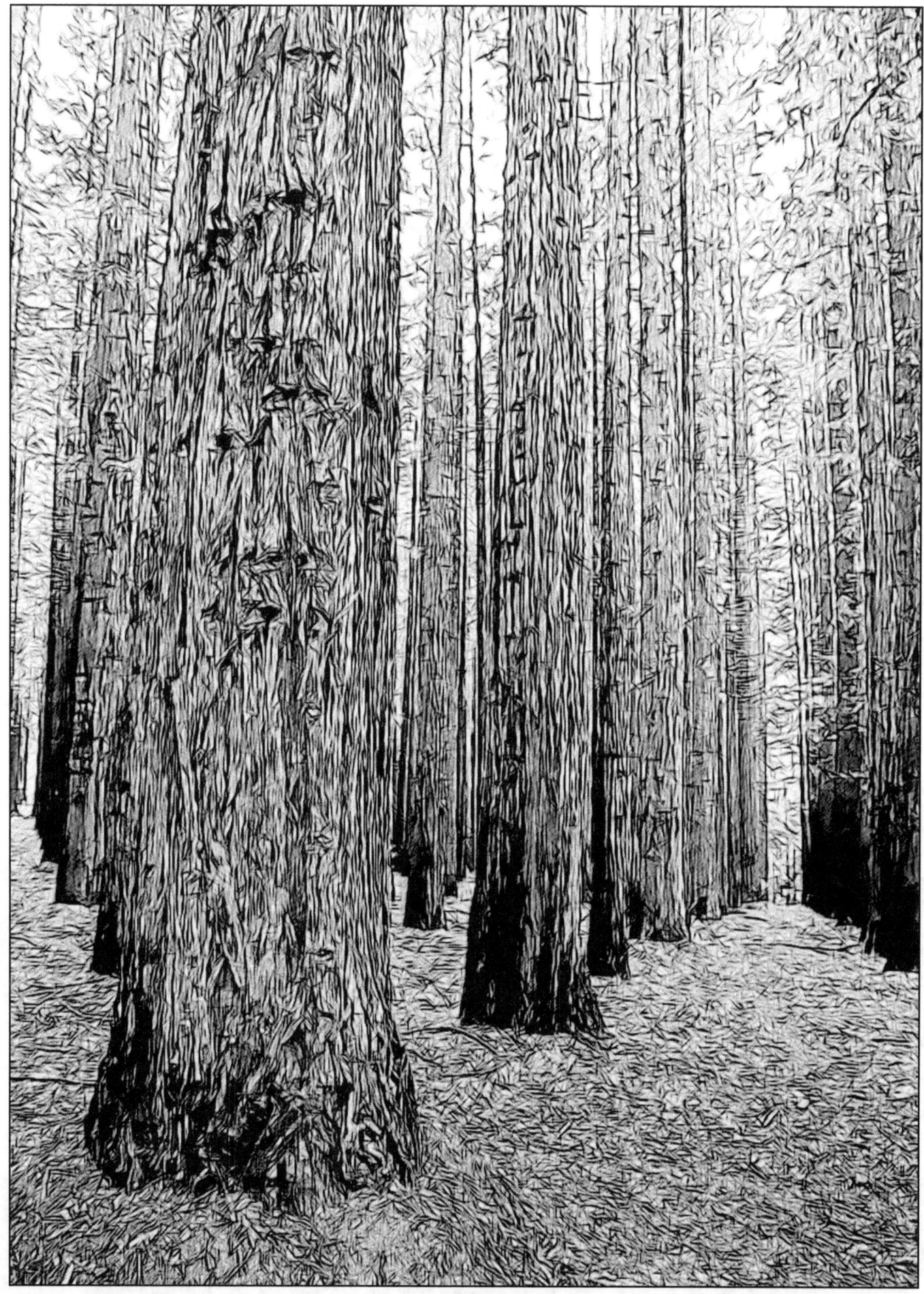

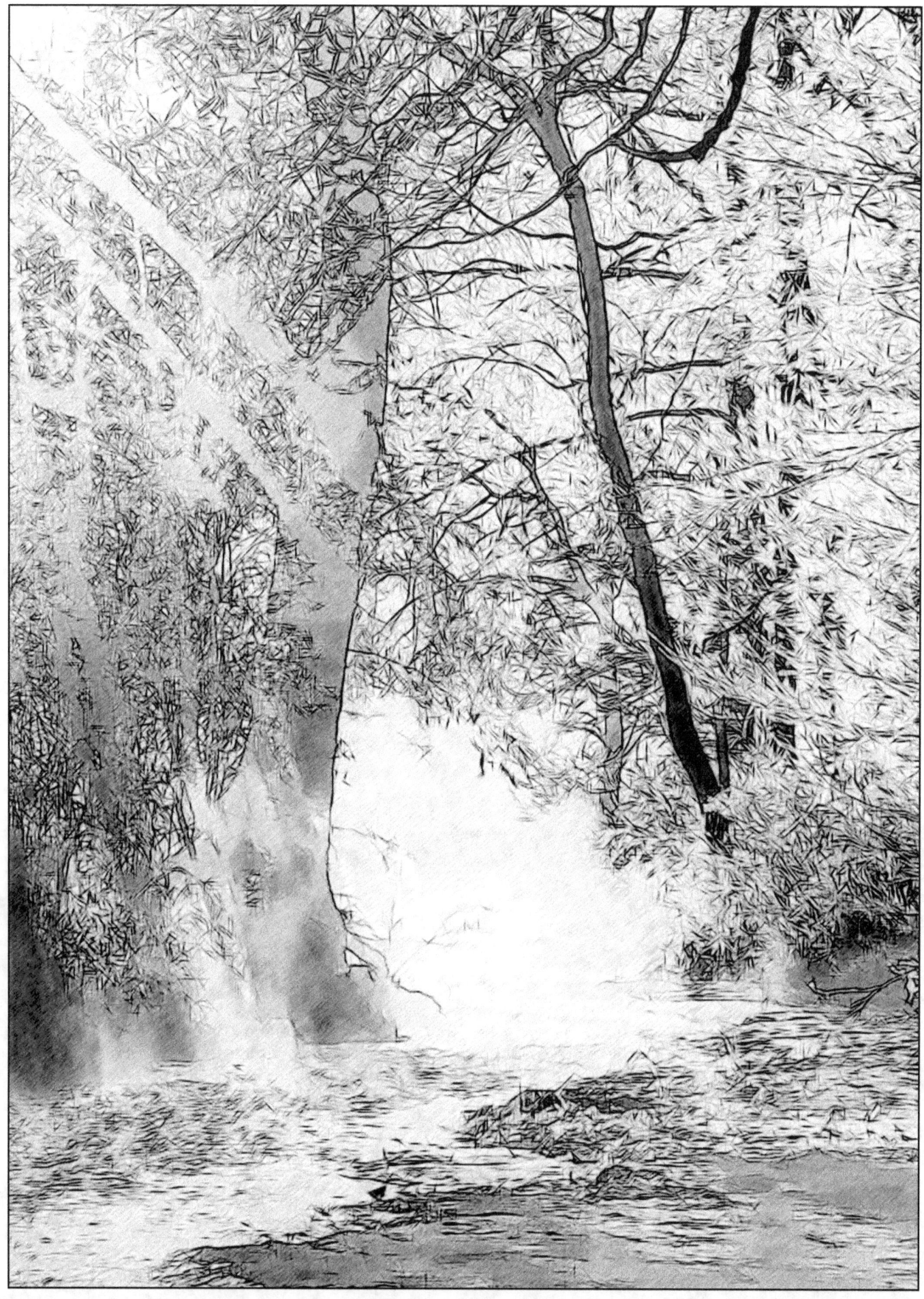

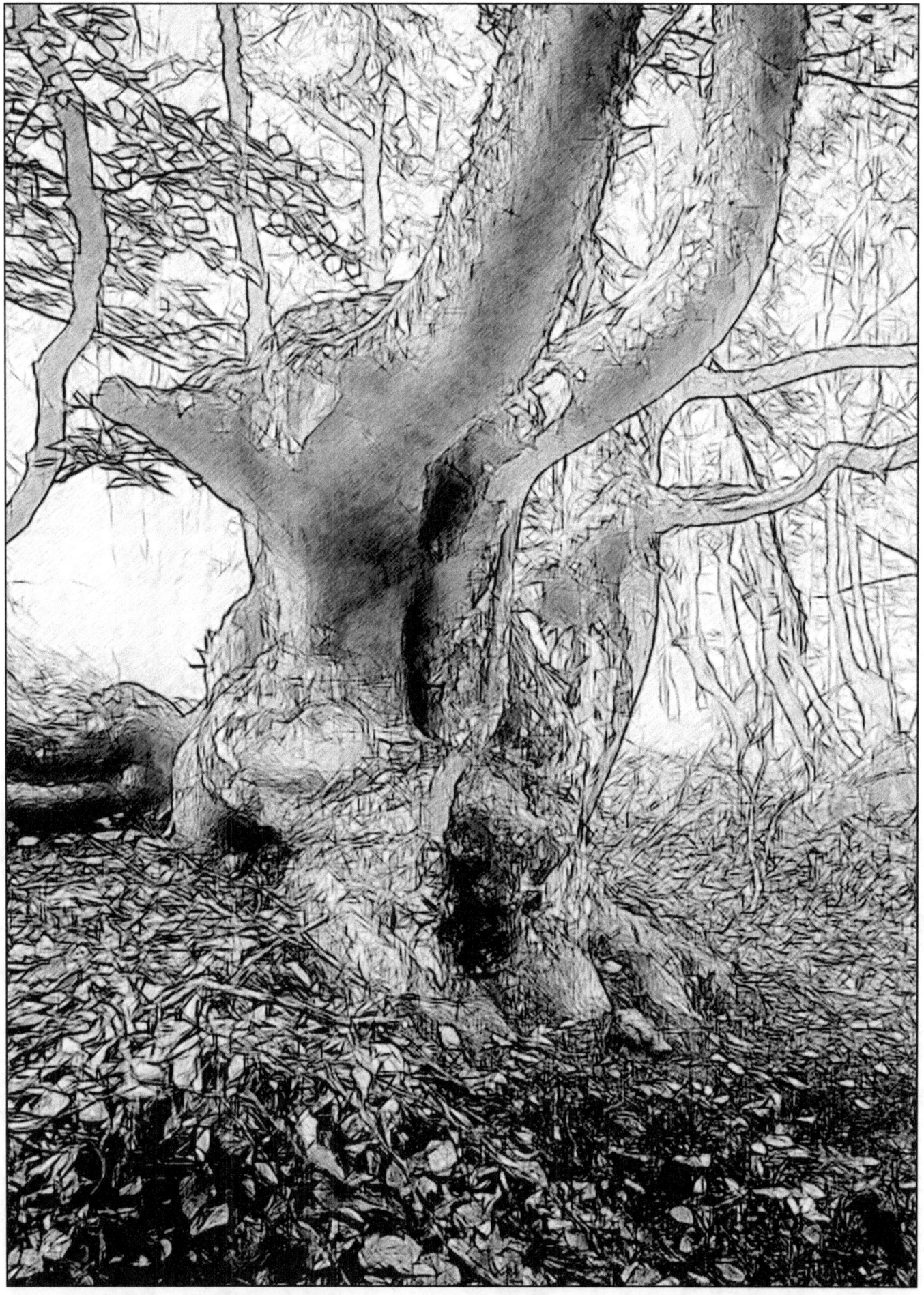

This is a Bleed Through Page If You Are Using a Coloring Marker or Pen!
Find Other Great Titles By searching for Coloring Therapists on Your Favorite Book Retailer
Amazon.Com | Barnes & Noble (BN.Com) | Books A Million (BAM.Com)

Coloring Therapists
STRESS RELIEVING COLORING ACTIVITIES

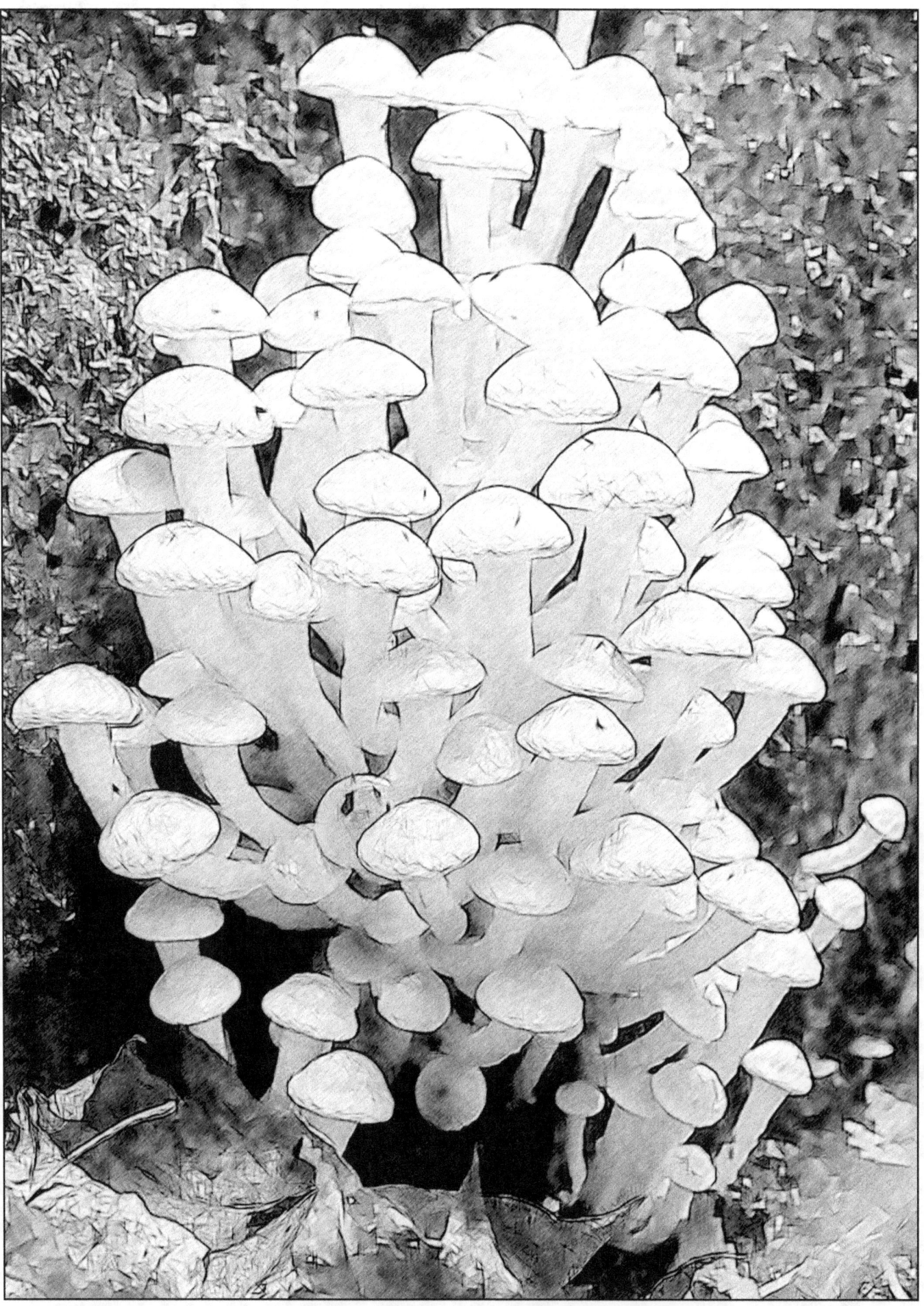

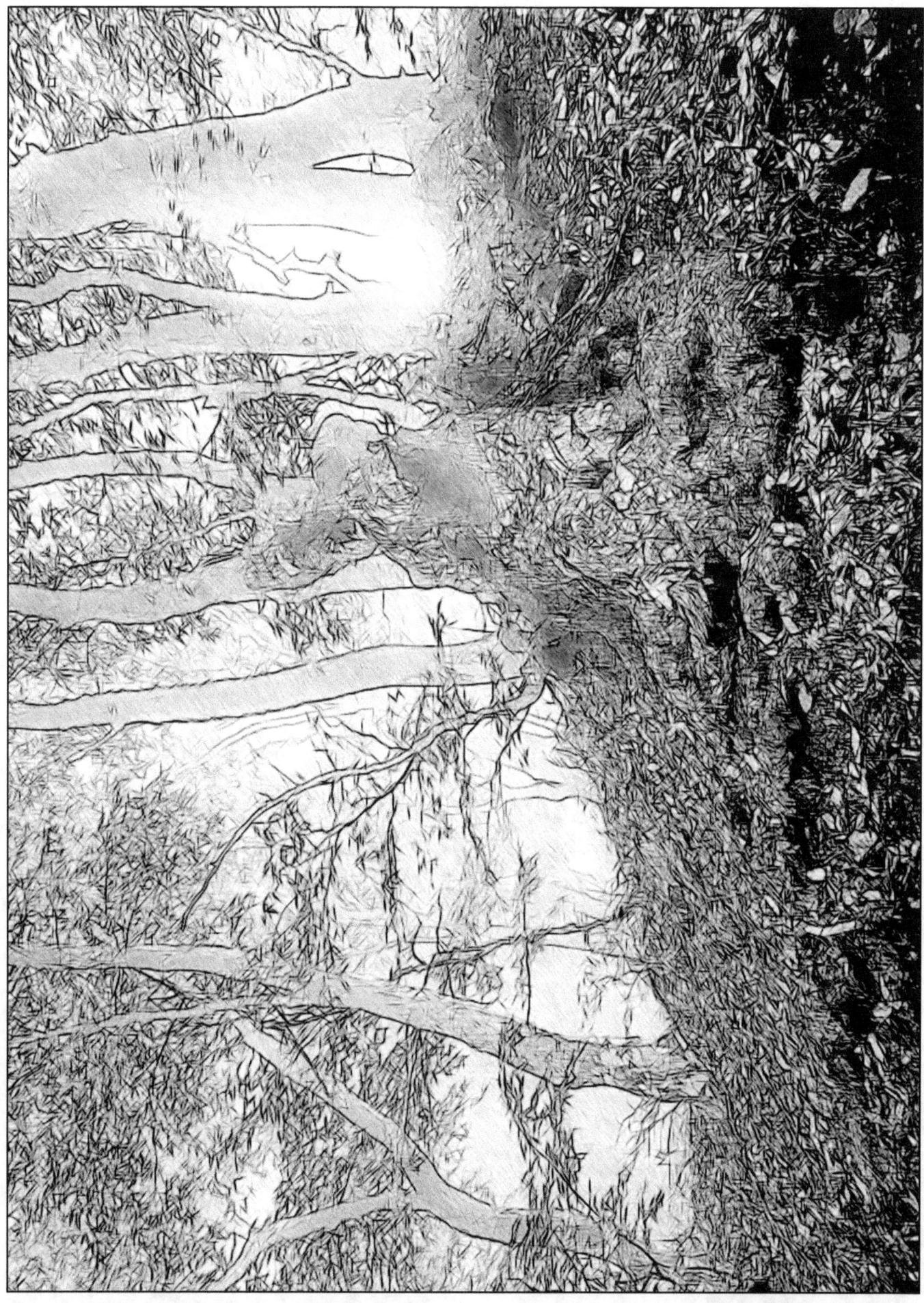

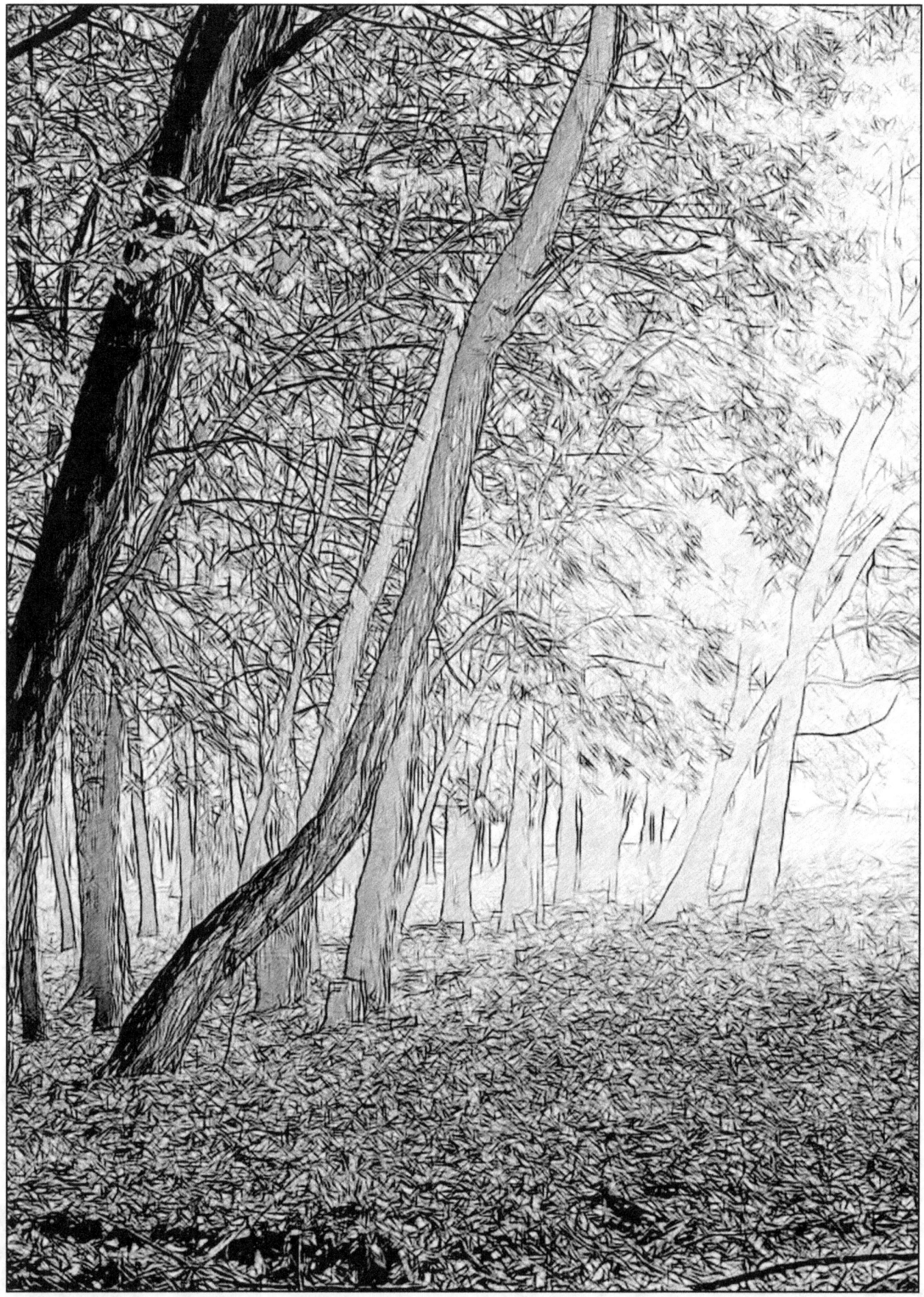

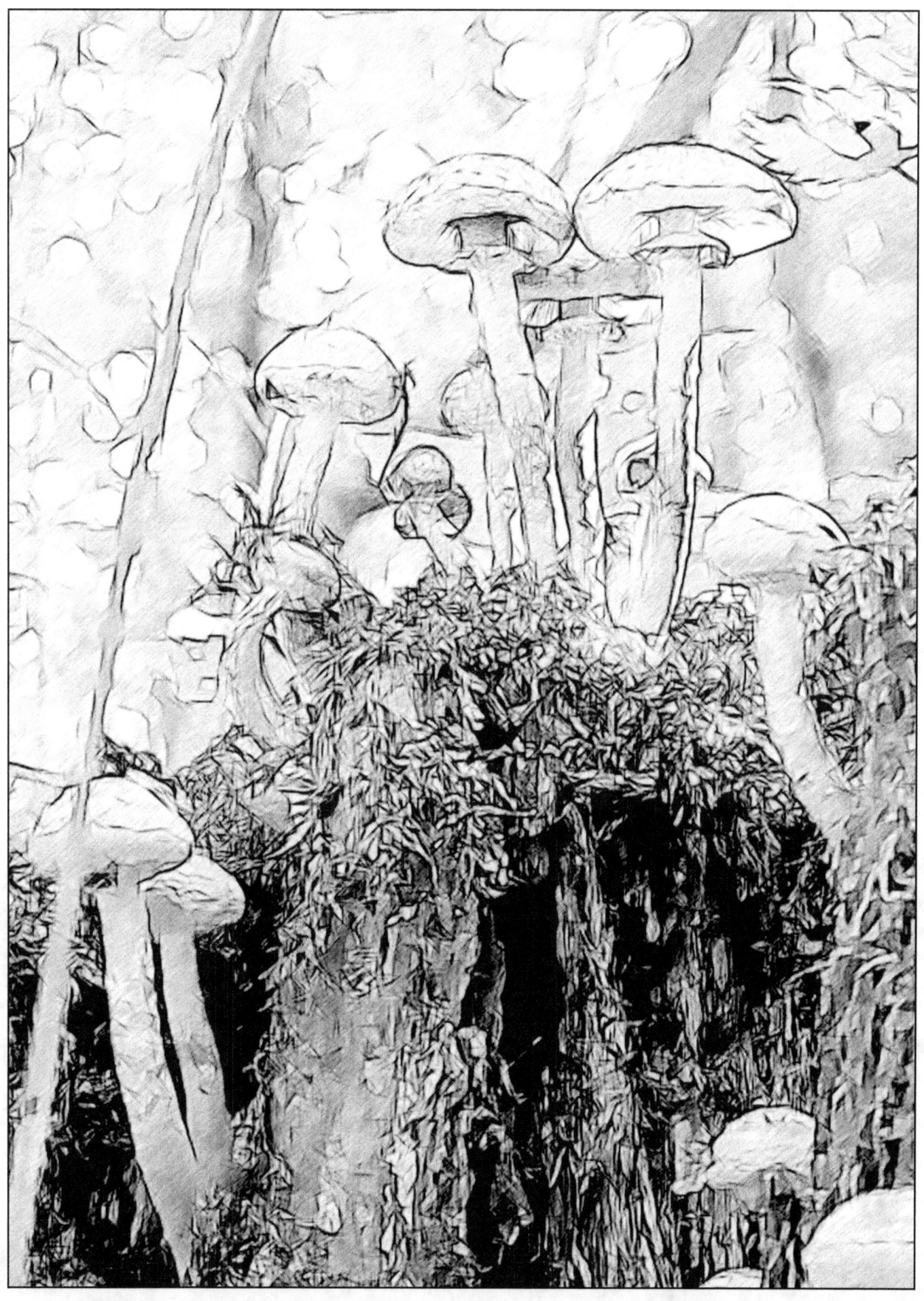

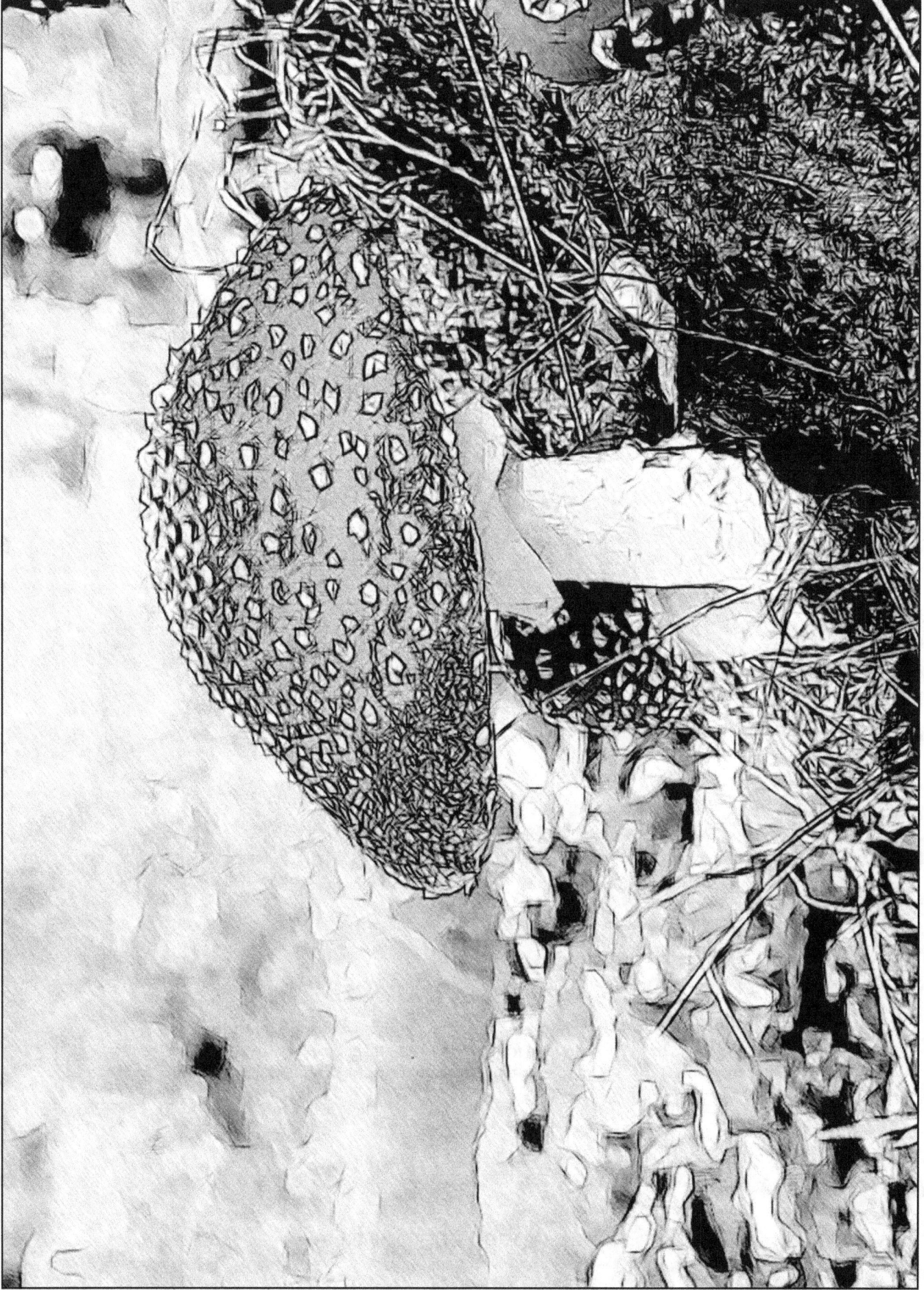

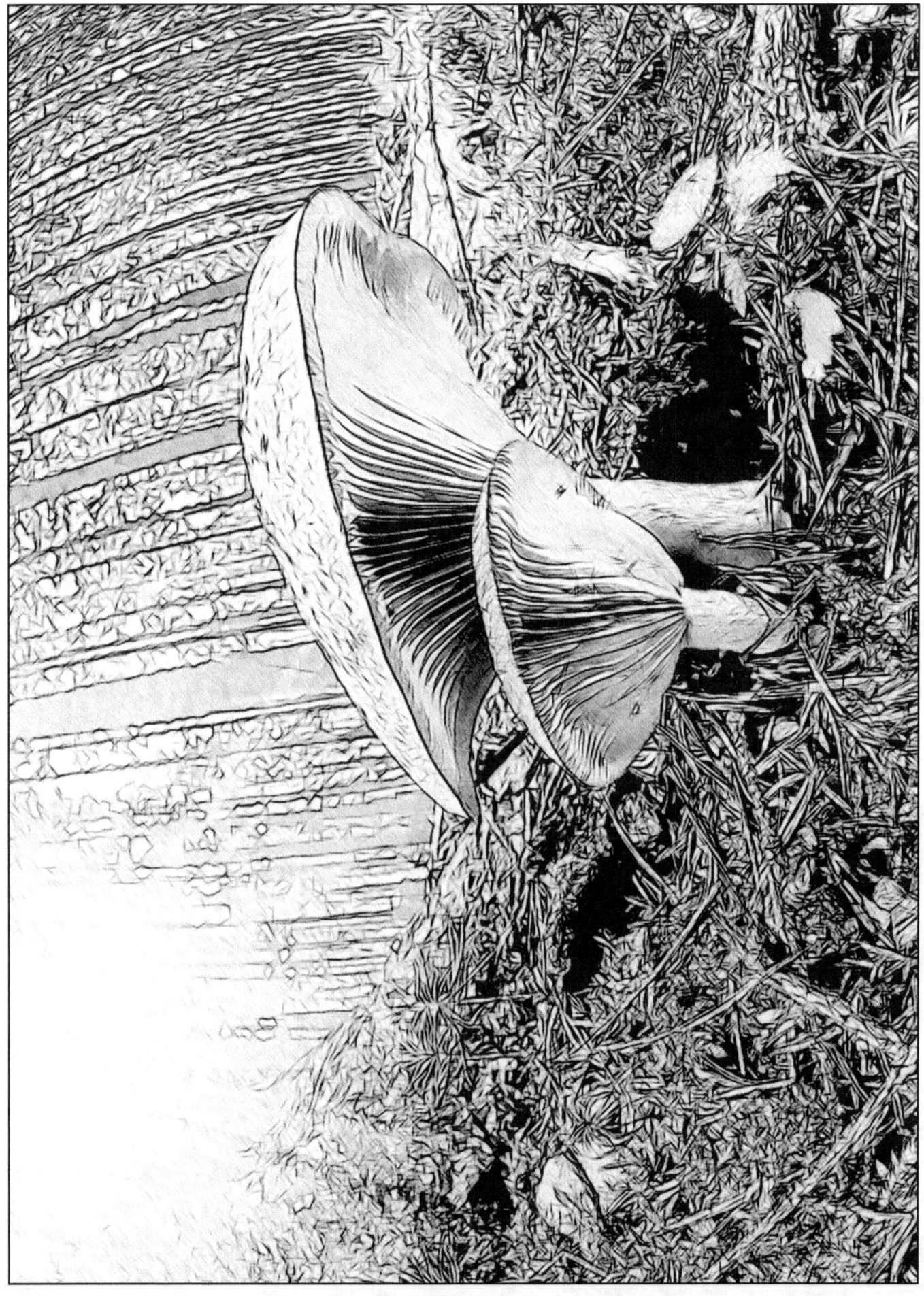

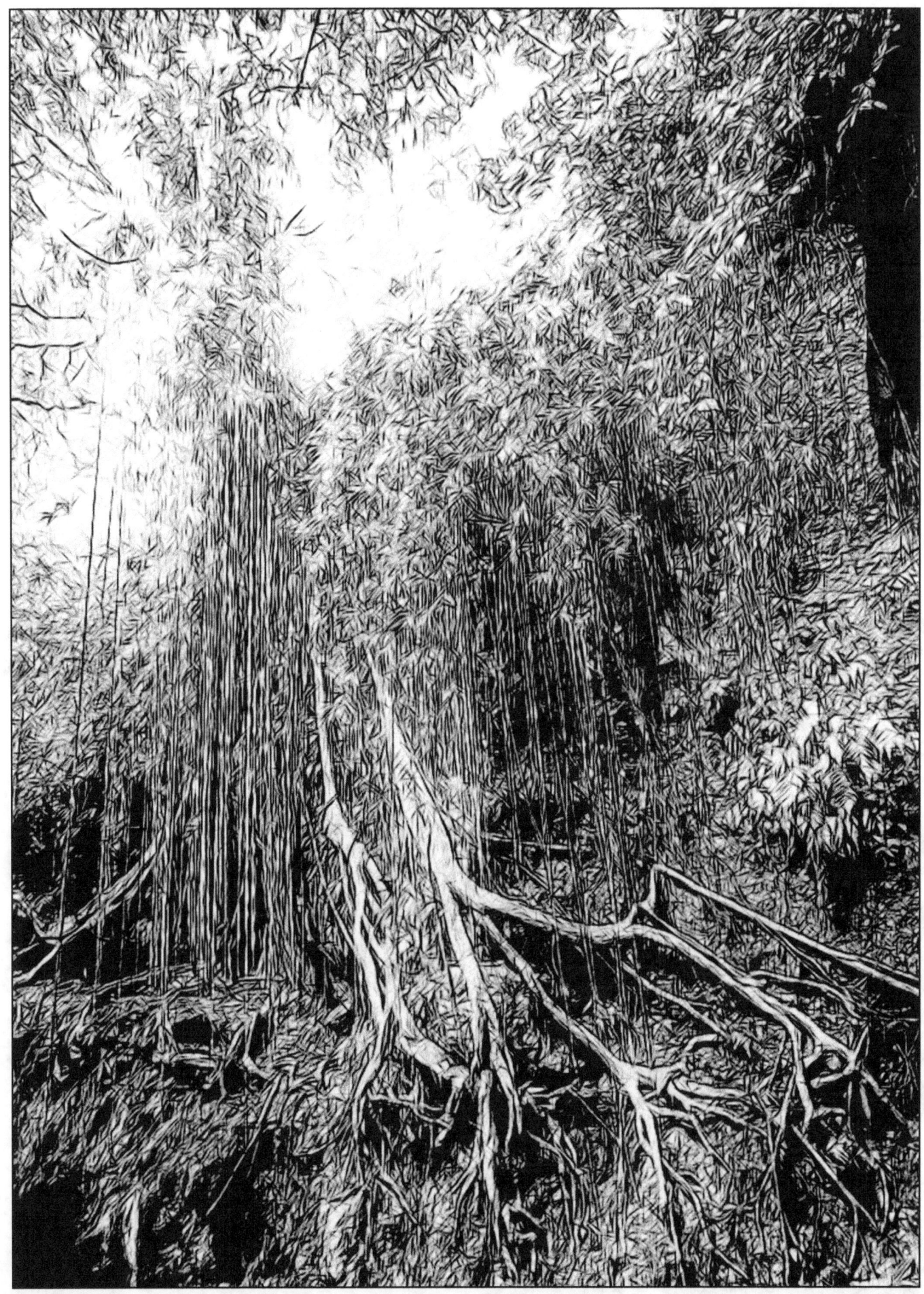

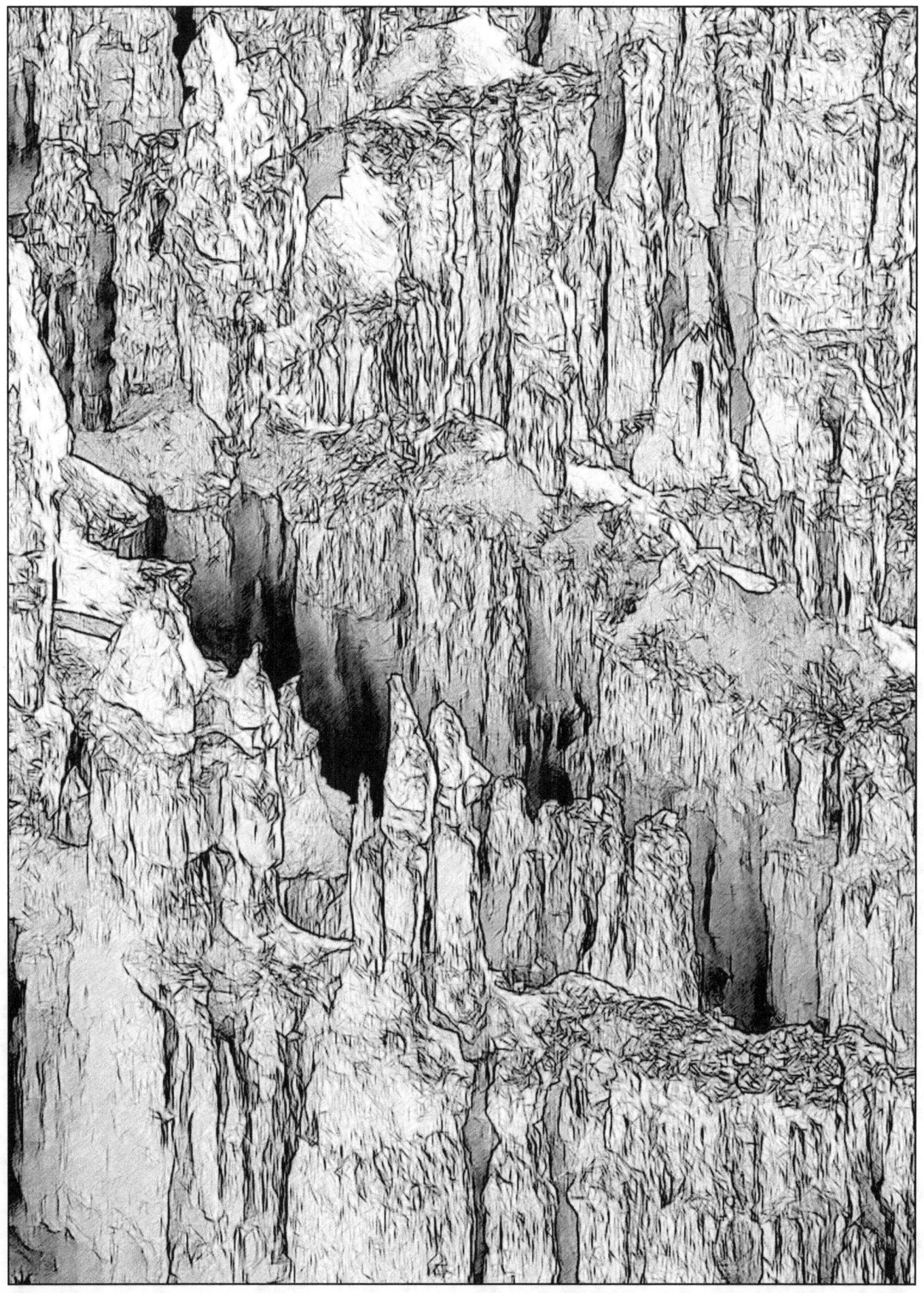

This is a Bleed Through Page If You Are Using a Coloring Marker or Pen!
Find Other Great Titles By searching for <u>Coloring Therapists</u> *on Your Favorite Book Retailer*
Amazon.Com | Barnes & Noble (BN.Com) | Books A Million (BAM.Com)

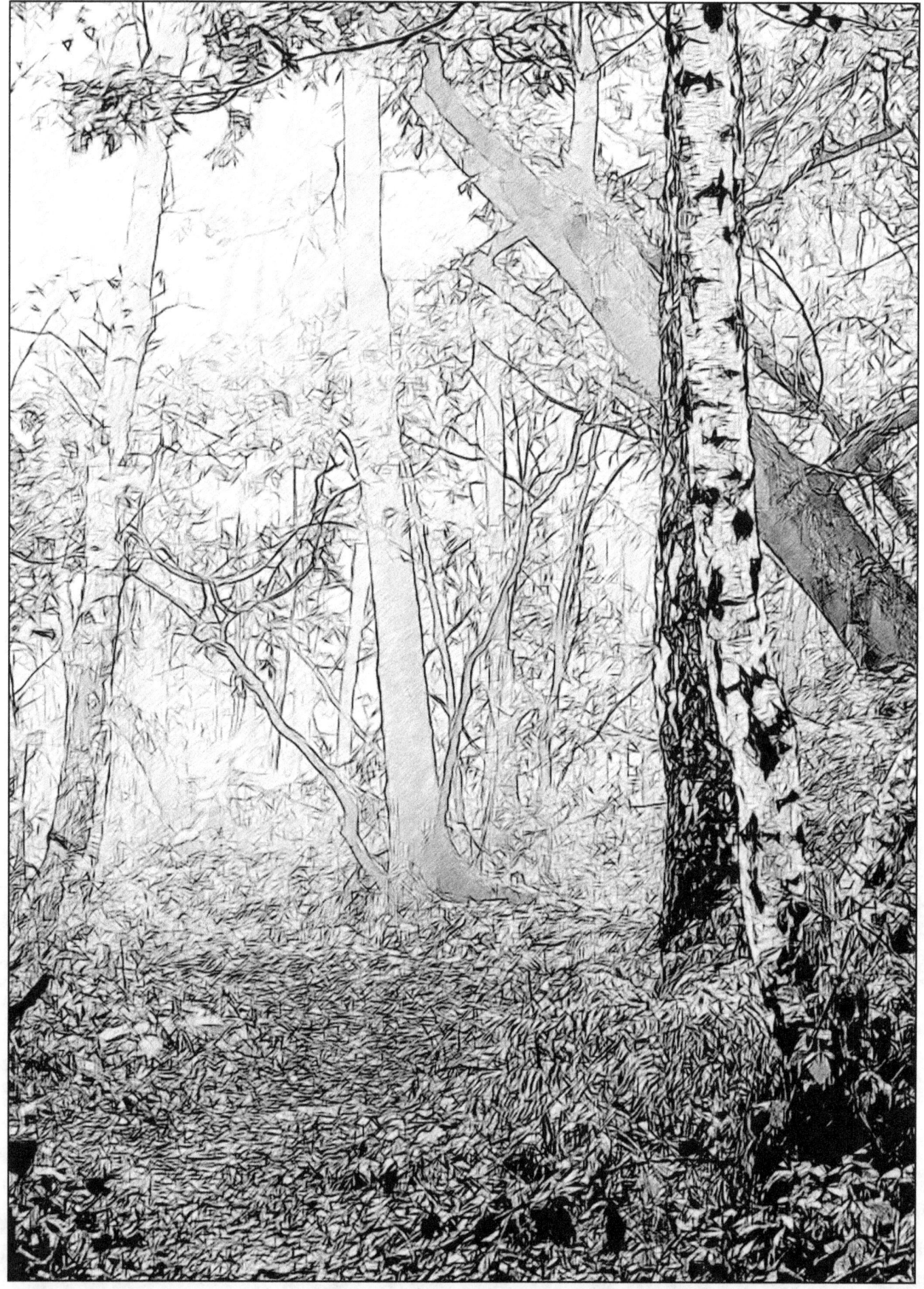

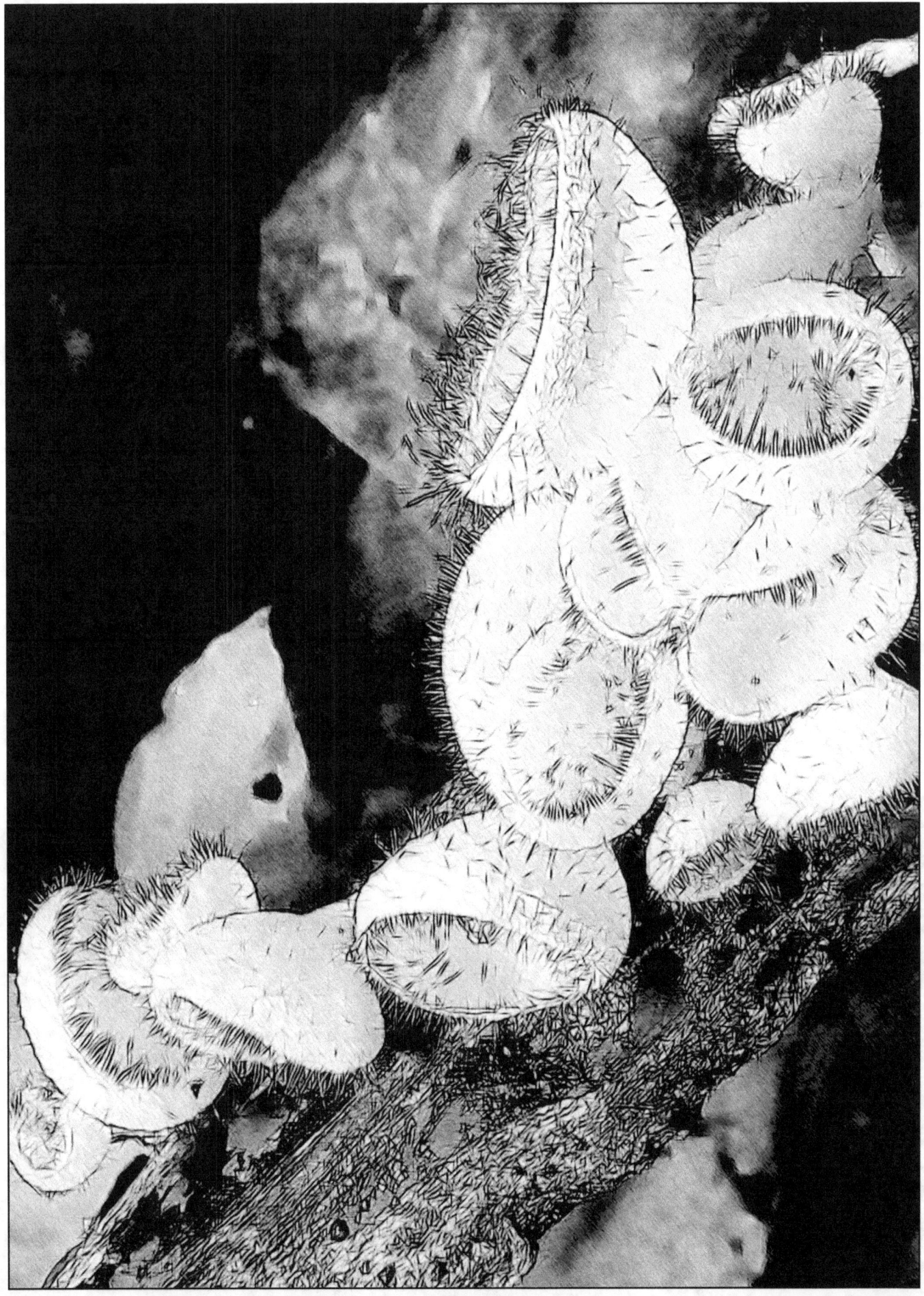

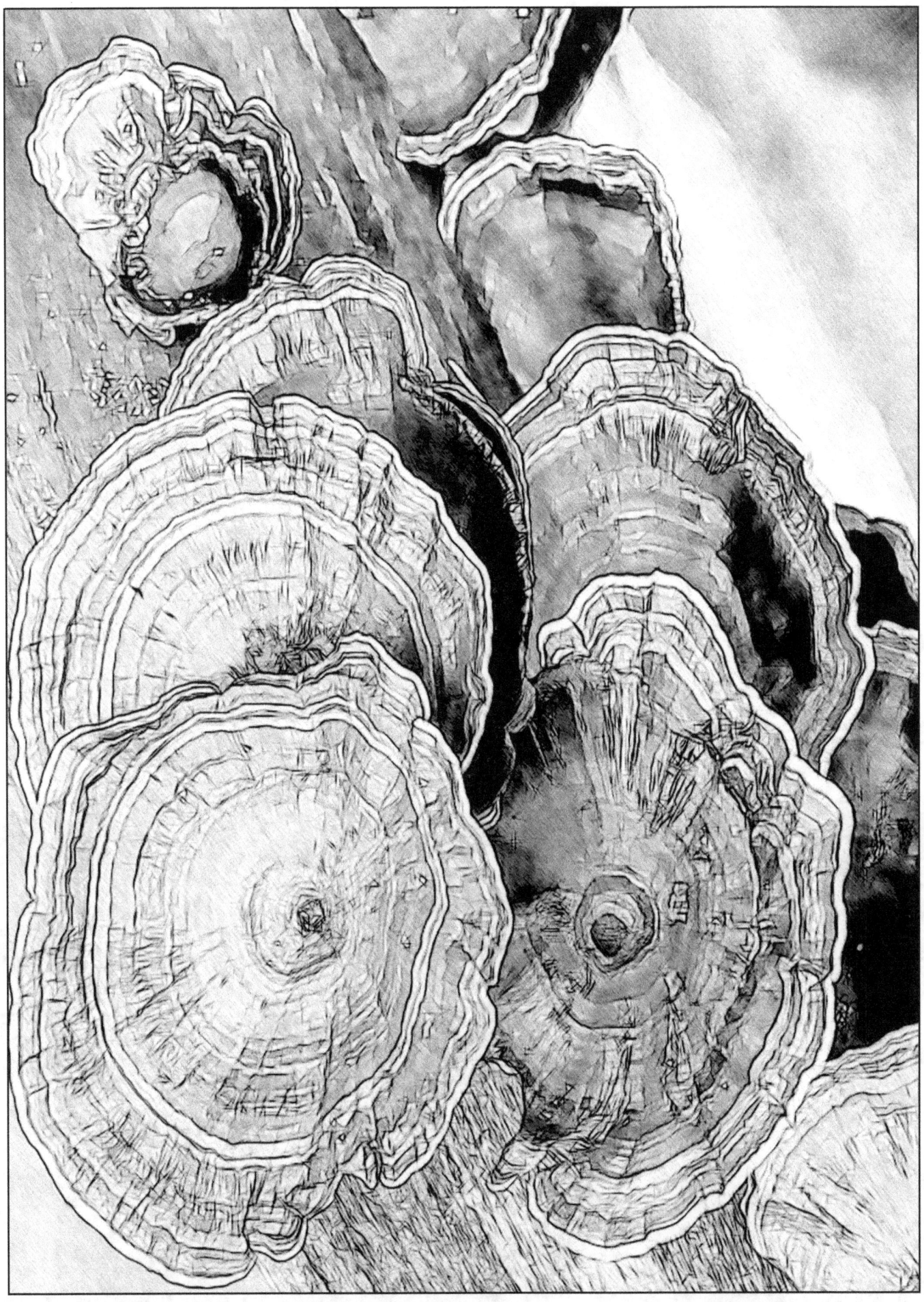

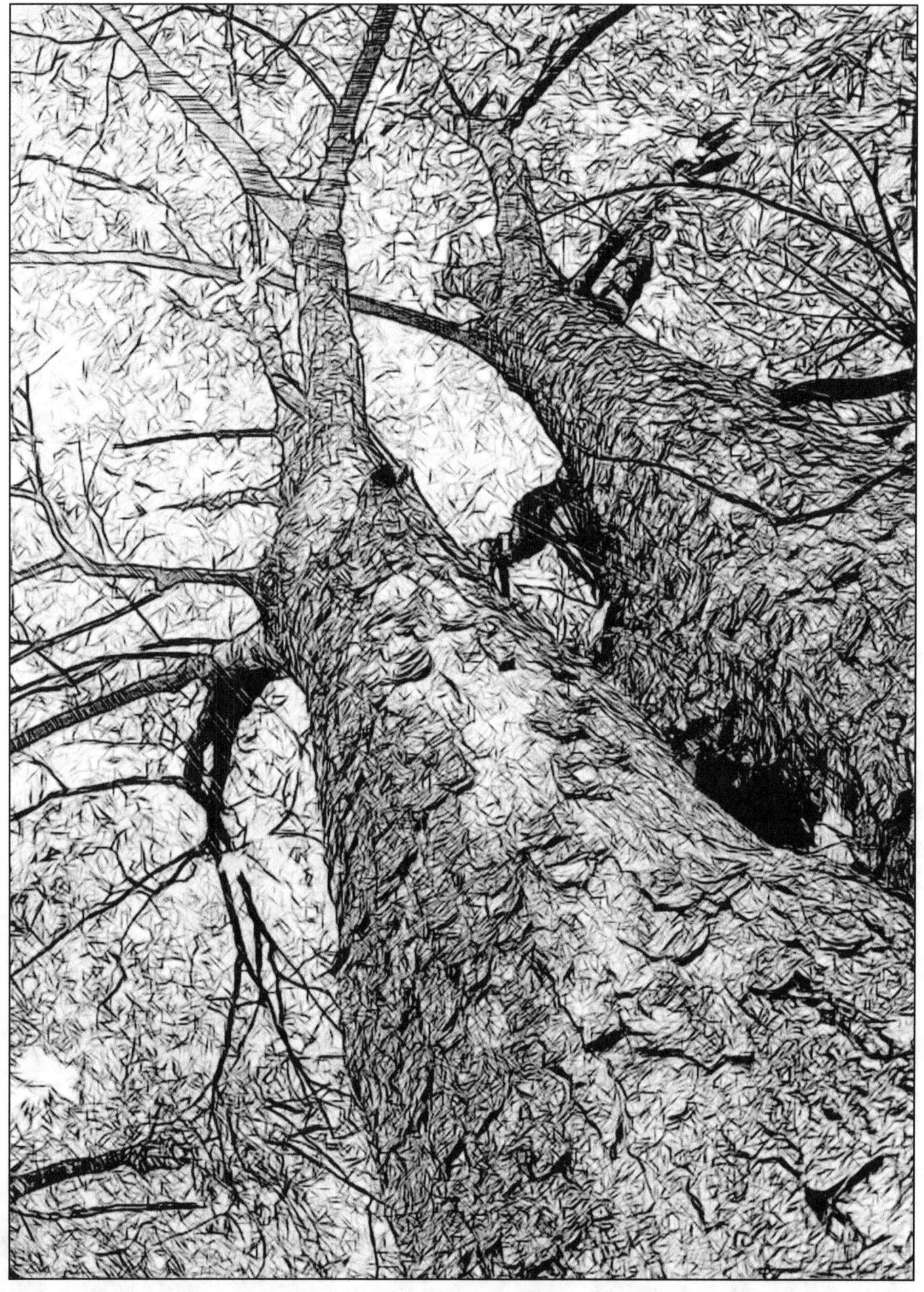

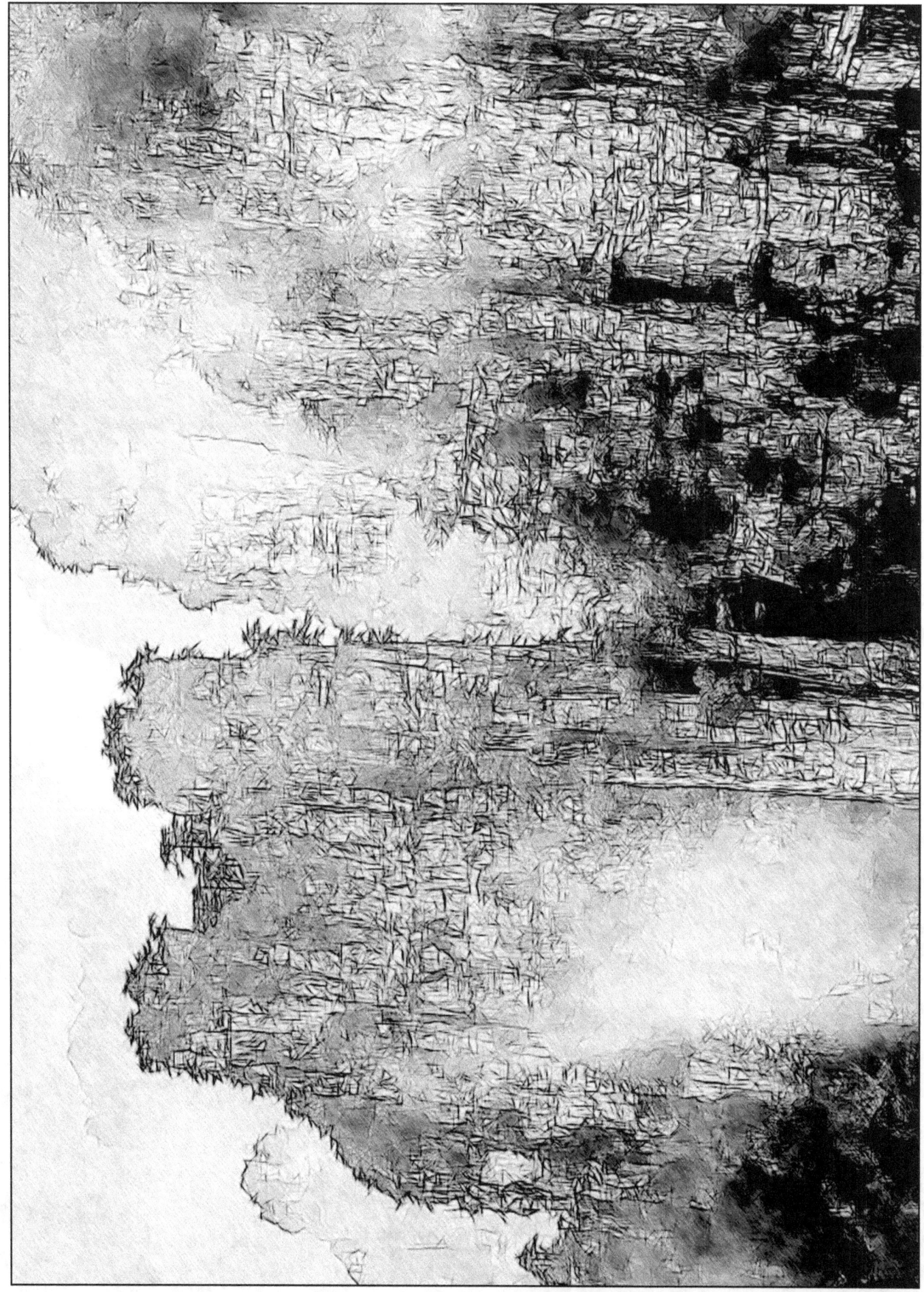

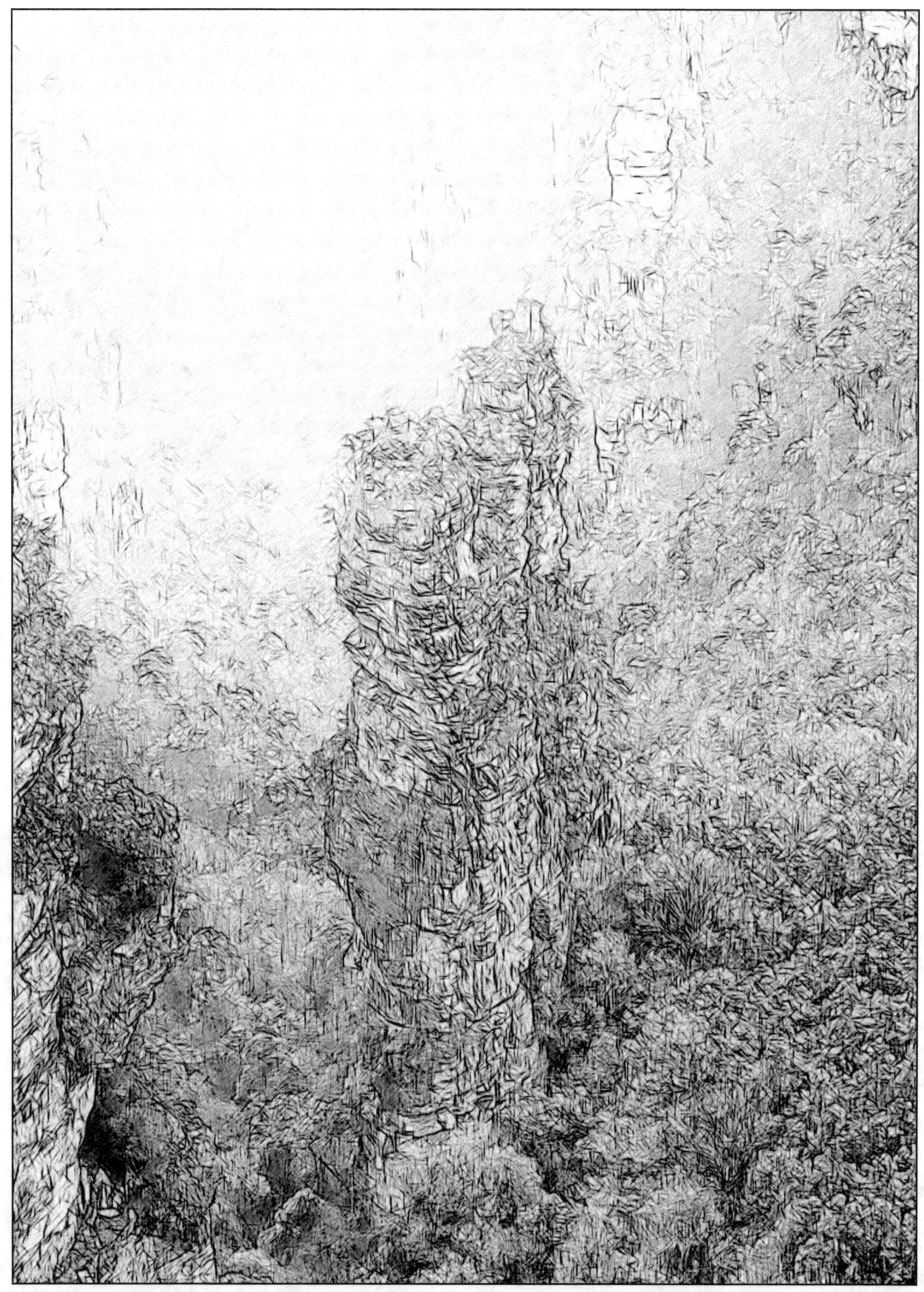

www.ingramcontent.com/pod-product-compliance
Lightning Source LLC
Chambersburg PA
CBHW081159180526
45170CB00006B/2140